趣玩 大自然 100個遊戲

符合SDGs主題+STEAM教育

黃京澤 著　葛增娜 譯

주머니 속 자연놀이 100
Copyright © 2022 by Hwang kyung taek
All rights reserved.
Traditional Chinese copyright © 2025 by GOTOP INFORMATION INC.
This Traditional Chinese edition was published by arrangement with
Slow & Steady Publishing Co
through Agency Liang

大自然會主動跟你說話

大自然是最好玩的遊戲場

　　小朋友在遊戲中感到開心和幸福，同時也學習許多人生所需的知識。在最好玩的遊戲場——大自然裡，盡情跑跳玩樂的孩子，創意、體力、感性、社會性也會隨著身高不斷成長。

　　不過究竟要在哪裡玩什麼、什麼樣的遊戲會有幫助、要多少人一起玩、父母或老師是否要陪在身邊等，這些疑問會讓想要嘗試的人卻步。因此，在本書裡介紹孩子們在自然中可以盡情玩樂的 100 個遊戲。

從八類遊戲中挑選組合

　　遊戲也需要均衡和節奏。例如一開始選擇和旁邊的朋友對視、擁抱，或是熟悉周遭環境的遊戲，可以讓身心變得比較放鬆。玩得喘不過氣時，可以坐在樹蔭下玩動腦思考遊戲，接著再以分享感受的方式來作為結束。

收錄在本書的 100 個自然遊戲，根據類型分為破冰暖身遊戲、五感觀察遊戲、動腦思考遊戲、融入自然遊戲、發洩精力遊戲、團隊合作遊戲、藝術創作遊戲、結尾收心遊戲。

　　只要從這八種類型中各選出一個遊戲，就可以成為完整的自然遊戲組合，讓孩子們在大自然中玩一、兩個小時絕對沒問題。

精選 100 個自然遊戲

　　韓國很早就推出鼓勵孩子在大自然裡遊玩的圖文書，後來熱銷再版時，不僅重新編排並增加了很多內容。把 50 個遊戲更換成全新的自然遊戲，並且對原來的 50 個遊戲進行了簡化，讓人們可以更加輕鬆地體驗自然，同時也能更深刻地感受到自然的魅力。

讓孩子自己體會遊戲的樂趣

當老師和父母介入的越多,孩子所享受到的樂趣就會越少。組別名字也好,懲罰也好,最好都讓孩子自己決定。當他們深深愛上某一個遊戲而大喊「再一次」時,就讓他們再玩一次。但這時要讓他們觀察並了解其他人是否也想再玩一次,是不是一樣覺得很好玩。

希望這本《趣玩大自然 100 個遊戲》,隨時隨地都能讓你和孩子玩得開心、盡興!

黃京澤

從森林裡找到的玩具，
是讓遊戲更好玩的材料

樹葉

每一個樹葉的形狀都不同，所以玩法無窮無盡。

樹枝

有各種玩法，可以在地上畫線或圓、做鳥巢、堆起來或玩投擲遊戲。

樹幹

倒在森林裡漸漸腐爛的樹幹也是很好的遊戲材料，可以爬上去玩，或是當成鼓來打擊也很有趣。

石頭

丟擲、堆成塔、丟進圓圈裡等。玩過幾遍之後，就會知道挑選好石頭的訣竅。

各種果實

可以像石頭一樣應用於各種遊戲，而且觀察不同的形狀、觸感、重量、聲音等也很有趣。

粗繩

可以玩多人跳繩、把兩端打結變成火車、也可以拿來在地上圍成圓圈。

細繩

可以像蜘蛛網一樣結網,也可以綁在樹之間掛上展示品。

木製夾子

可以把樹葉或紙張夾在繩子上,也可以玩夾在衣服上的遊戲。

大塊白布

可以像圖畫紙在上面作畫,或是收集自然素材之後攤在上面觀察。摺起來小巧輕便容易攜帶。

小塊布

約手帕的大小,可以用來遮住眼睛,或綁在當鬼的人的手腕上。

袋子

可以放進果實或石頭等自然素材玩觸覺體驗遊戲。

紙盒

把自然素材放進紙盒後觀察,或是把果實放進去,玩聽聲辨物的遊戲。

牛皮紙膠帶

可以在現場立刻撕開當作便條紙使用。

紙張和筆

隨時都需要。

目錄

大自然會主動跟你說話 · 3

從森林裡找到的玩具，是讓遊戲更好玩的材料 · 6

🍄 破冰暖身遊戲

可以放鬆緊張的身心，快速跟陌生的自然、老師和其他人變成好朋友。

001 他說什麼？ · 16
002 大象握握手 · 18
003 手牽手，轉動身體 · 20
004 手牽手站起來 · 22
005 我愛唱反調 · 24
006 模擬大自然 · 26
007 沿著樹幹比一比 · 28
008 保護我 · 30
009 什麼改變了？ · 32
010 化身為自然素材 · 34
011 森林入場券 · 36
012 製作名牌 · 38
013 魔法筆 · 40

🍄 五感觀察遊戲

睜大眼睛觀察周遭，一定會有新的發現。

014 毛毛蟲望遠鏡 · 44
015 森林尋寶遊戲 · 46
016 獨一無二的自然博物館 · 48
017 森林賓果 · 50
018 找出同樣的形狀！· 52
019 找出同樣的葉子！· 54
020 找到不同的葉子！· 56
021 樹葉猜拳 · 58
022 樹葉拼圖 · 60
023 用手觀察 · 62
024 用耳朵觀察 · 64
025 用鼻子觀察 · 66
026 找出更長的 · 68
027 找出更重的 · 70

🍄 動腦思考遊戲

只要再思考一下就能輕易解決問題。
一起邊玩邊思考吧！

028 該怎麼排序呢？· 74
029 樹是怎麼長大的？· 76
030 丟松果 · 78
031 丟葛藤圈 · 80

032 堆石塔・82　　033 找到樹枝的平衡・84

034 楓樹種子飛行・86　　035 將種子傳播得更遠・88

036 創作昆蟲・90　　037 找出昆蟲・92

038 找出杜鵑鳥的蛋・94　　039 製土・96

🍄 融入自然遊戲

用全身感受自然，和自然合而為一的遊戲。

040 找到舒服的地方・100　　041 介紹我的朋友・102

042 寫給樹的一封信・104　　043 找出胖胖的樹・106

044 這是我的巢！・108　　045 颱風來了！・110

046 如果我是鳥・112　　047 趴低一點！・114

048 浣熊在哪裡？・116　　049 多長一歲・118

050 光合作用猜拳・120　　051 森林猜拳・122

🍄 發洩精力遊戲

盡情跑跳玩樂的遊戲。

052 高一點、再高一點 · **126**
053 春天冬天青蛙跳 · **128**
054 腳不落地 · **130**
055 綠色踏腳石橋 · **132**
056 接力跳遠 · **134**
057 樹為什麼會死？ · **136**
058 吊樹木單槓 · **138**
059 接力踢松果 · **140**
060 越小越好 · **142**
061 許願 · **144**
062 丟遠 · **146**
063 爬樹 · **148**

🍄 團隊合作遊戲

就像住在大自然的各種生物，大家互助合作一起完成遊戲吧！

064 浣熊大便 · **152**
065 自然素材接力賽 · **154**
066 立樹 · **156**
067 抽樹 · **158**

068 架樹塔 · 160　　069 搬石頭 · 162

070 用樹枝釣魚 · 164　　071 運水 · 166

072 走獨木橋 · 168　　073 換位置 · 170

074 滾橡實 · 172　　075 打造祕密基地 · 174

🍄 藝術創作遊戲

用自然素材進行藝術創作。

076 森林展覽會 · 178　　077 找出同樣的顏色 · 180

078 楓葉漸層 · 182　　079 拓印樹葉 · 184

080 這個像什麼呢？ · 186　　081 變出無限可能 · 188

082 森林設計師 · 190　　083 森林服裝秀 · 192

084 是不是這裡？ · 194　　085 製作森林樂器 · 196

086 森林作曲家 · 198　　087 完成圖畫 · 200

088 落葉雕塑家 · 202
089 楓葉色紙 · 204
090 楓葉彩繪玻璃 · 206
091 變成毛毛蟲 · 208
092 樹的生日派對 · 210
093 用水畫畫 · 212
094 用土畫畫 · 214
095 年輪拼圖 · 216

🍄 結尾收心遊戲

適合放在最後的遊戲，
請用回顧一天的方式和大家分享。

096 授粉猜拳 · 220
097 你今天過得好嗎？ · 222
098 抓拐杖 · 224
099 種樹的人 · 226
100 全都在種子裡 · 228

破冰暖身遊戲

適合與孩子們第一次在森林中見面時進行的遊戲。不論是什麼活動，最重要的就是引發動機。按照以下順序進行：打招呼、暖身、培養對大自然的好奇心，然後準備好進入大自然。這些遊戲主要是透過律動和體操來暖身，身體暖開了，心情自然也會跟著放鬆。比起用說明或教學的方式，讓孩子們在輕鬆自在的氛圍中自然地親近自然更理想。

001 他說什麼？

孩子們注視著主持人的嘴巴，就會漸漸進入遊戲裡。

1 這是一個不發出聲音，只用嘴形猜單字的遊戲。
2 主持人先開始，接下來換答對的人出題。
3 儘量從動物或自然裡的物品出題。
4 當孩子稍微放鬆沒那麼拘謹時，再自然地結束遊戲。

▶ 第一個遊戲最好能迅速吸引孩子們的注意。當孩子們直盯著主持人的嘴巴時，就會不自覺地投入遊戲。

▶ 請將作答的機會讓給先舉手的孩子。如果急著想回答卻沒有舉手，遊戲的樂趣就會因此減少許多。

| 季節 ▶ 不拘 | 地點 ▶ 不拘 | 人數 ▶ 不限 |

002 大象握握手

和朋友握手,邊玩數字遊戲。

1　請大家比出象鼻子。
2　大象要按照主持人說的隻數聚在一起。
3　聚在一起的人要用鼻子握手。
4　主持人逐漸說出較大的數字,讓大象們繼續握手。
5　也可以分成兩組進行遊戲。

▶ 真正的大象在見到同伴時,其實也都是用鼻子握手喔。這是一個能讓朋友們互相握手、進行肢體接觸的遊戲。

▶ 握手時,主持人如果說些像「兩隻大象坐著、兩隻大象站著握手」這樣的指令,會讓遊戲更有趣。

| 季節 ▶ 不拘 | 地點 ▶ 需要有一點空間 | 人數 ▶ 20人上下的雙數 |

003 手牽手，轉動身體

可以放鬆身心的緊張。

1 兩人一組，互握雙手。
2 在不放開手的狀態下，轉動身體。
3 一開始握手，接下來握住對方的手肘，最後握住對方的肩膀，漸漸提高難度。

▶ 儘量安排身高相近的小朋友一起玩。
▶ 人數較多時，可以換搭檔多玩幾次，遊戲會更有趣。
▶ 除了兩個人玩之外，也可以一個人和樹玩。將雙手平貼在樹面上，轉動身體。姿勢越低，難度越高。

嘿咻！

注意，平貼在樹面上的手掌不能離開。

🍄 ｜**季節** ▸ 不拘｜ ｜**地點** ▸ 不拘｜ ｜**人數** ▸ 2人以上｜

21

004 手牽手站起來

和朋友們手牽手合力完成吧!

1　兩人一組,雙手互握坐在地上。
2　主持人說開始,兩人同時拉手,從原地站起來。
3　成功了就逐漸增加人數繼續遊戲。
4　最後,讓所有參加的人一起挑戰!

▸ 人數越多越難成功,但不要輕易放棄,在朋友的幫助下努力站起來吧!

▸ 在坐著的狀態下站起來時,很多人想要抵住彼此的腳底站起來,但這樣反而不容易成功。不妨拉遠距離,在手臂拉直的狀態下施力,比較能借助彼此的力量站起來。不過,與其直接告訴孩子們方法,不如讓他們自己嘗試,摸索出訣竅。

| **季節** ▶ 不拘 | **地點** ▶ 平坦的地方 | **人數** ▶ 10 人以上 |

005 我愛唱反調

做相反動作,培養專注力,同時也能暖身。

1 請孩子做出跟主持人指令相反的動作。
2 說出「坐下」、「不要動」、「睜開眼睛」等簡單的指令。
3 給予沒有做出相反動作的孩子一個小懲罰。

▶ 可以先用簡單的動作開始,最後說出「抱樹」、「不要抱樹」等指令,讓孩子接觸自然。
▶ 如果有孩子想要下指令,也可以讓他們來主持遊戲。

|季節 ▶ 不拘| |地點 ▶ 不拘| |人數 ▶ 不限|

006 模擬大自然

透過觀察和模仿大自然，進一步放鬆身體的暖身活動。

1 主持人模擬自然界的形態、動物的姿勢或大自然中的元素，請大家跟著做做看。

2 每個人輪流想一個模擬大自然的動作，請其他小朋友跟著做做看。

▶ 不一定只能模擬周遭看到的事物，也可以模擬老虎或大象等動物。

▶ 想出動作的人要同時說明必須注意哪個部分，並進行引導。

|季節▶不拘| |地點▶不拘| |人數▶不限|

007 沿著樹幹比一比

用身體測量樹的大小,激發對大自然的好奇心。

1 站在大樹前。
2 用手指頭從地上的根開始,沿著樹幹比到樹枝。
3 一直比到最遠的樹枝。
4 比到末端之後,走到那個樹枝下方。
5 觀察其他人的位置,估算那棵樹的大小。

▶ 樹木遠比我們想像的還要大。除了我們眼睛能看到的樹枝,還有深入地下的樹根。這麼想的話,就會覺得樹木看起來更龐大了。

▶ 樹木的多種用途和我們的生活息息相關,而且它們的壽命很長、長得高大,因此和人類的關係緊密。

比到樹枝的末端站在下方觀察，就可以估算樹的大小。

| **季節** ▸ 不拘 | **地點** ▸ 有大樹的地方 | **人數** ▸ 不限 |

29

008 保護我

在製作森林守護神的過程中,讓孩子們更熟悉自然素材。

1 請孩子各自在森林裡找到喜歡的自然素材。
2 把找來的物品當作是自己的朋友或是「守護神」,放在森林裡最大的樹下方。
3 在放下來時念著「請保護我,讓我不會受傷」,然後走進森林裡。

▶ 可以請孩子幫自然素材取名字,並分享取這個名字的原因。
▶ 可以替自然素材畫上眼睛、鼻子和嘴巴。
▶ 對於年紀較小的孩子,營造童話故事般的氛圍會更有效果。
▶ 結束當天的遊戲後,回來時要向森林守護神道謝,然後把自然素材放回原來的地方。

| 季節 ▶ 不拘 | 地點 ▶ 森林 | 人數 ▶ 15 人上下 |

009 什麼改變了？

透過觀察及觸摸自然素材，和森林快速變好朋友。

1. 請孩子各自在森林裡找到喜歡的自然素材。
2. 在地上鋪白色的布，把孩子拿回來的自然素材放上去。
3. 一起觀察有哪些自然素材，和孩子分享關於森林的事情。
4. 主持人請大家閉上眼睛，把一個自然素材藏起來或調換位置，請大家猜猜看發生了什麼變化。

▶ 將自然素材放在白色布上，比放在地上看起來更醒目，也能提高孩子們的專注力。

▶ 白布代表森林的縮小版。這樣的出題遊戲有助於掌握孩子對大自然的了解程度和個性。

▶ 重複幾次後，可以讓孩子清楚地記住自己找來的自然素材。

來～請大家閉上眼睛。

放在這裡的樹枝不見了！

| 準備物品 ▶ 白布 | 季節 ▶ 不拘 | 地點 ▶ 不拘 | 人數 ▶ 不限 |

010 化身為自然素材

和自然素材融為一體，跟隨它一起行動。

1 請孩子各自找到自然素材，放在布上並坐下。
2 主持人拿起布上的其中一個素材，素材的主人就要回答「是我的！」然後站起來。
3 如果選兩個素材，就會有兩個孩子站起來。
4 主持人操縱自然素材，做出跳舞、坐下再站起來，或互相擁抱等動作，請孩子用動作模仿。
5 最後，將相同數量的自然素材變成一組，進行分組遊戲。

▶ 遊戲中組隊的方式有很多種，與其強行讓孩子們分組，不如讓他們在遊戲過程中自然地成為一組更好。
▶ 這個遊戲可以讓孩子們透過肢體接觸變得更加親近。
▶ 下一些稍微難一點的指令，例如原地跳或翻滾等動作，也會讓遊戲變得更有趣。

| **準備物品** ▶ 白布 | **季節** ▶ 不拘 | **地點** ▶ 不拘 | **人數** ▶ 雙數 |

011 森林入場券

增添進入森林前的儀式感。

1. 主持人在森林入口處用倒下的樹幹做成路障,如果沒有自然素材也可以綁繩子示意。
2. 告訴孩子需要入場券才能進去,請孩子準備入場券。
3. 入場券可以是五顏六色的葉子、有洞的葉子、紅色果實等,主持人可以依照當時的情況出題。
4. 孩子們將找到的入場券交給主持人後,就可以進入森林了。

▶ 也可以把紙張分給孩子,讓他們自己設計入場券。主持人可以設定「會呼吸的森林」、「夏天的森林」等主題,或是讓孩子自由創作。

▶ 將每個人設計完成的入場券夾在繩子上、或放在路障上展示後,即可進入森林。

▶ 繩子要綁得比孩子的身高低,讓孩子交出入場券之後彎腰進入。以家庭為單位參加的團體,可以一起完成一張入場券。

|季節 ▶ 不拘| |地點 ▶ 森林入口| |人數 ▶ 不限|

012 製作名牌

為自己取一個適合森林的暱稱,並裝飾名牌。

1 準備透明證件套。
2 請大家各自撿一張樹葉。
3 用簽字筆在樹葉上寫下自己的名字或暱稱。
4 將寫好的樹葉放進證件套裡,掛在脖子上。

▶ 染紅的楓葉或掉落不久的落葉比較容易書寫。
▶ 除了名字之外,也可以畫畫來裝飾樹葉。

簽字筆或麥克筆比原子筆容易書寫。

| 季節 ▶ 秋天 ~ 冬天 | 地點 ▶ 森林、公園等 | 人數 ▶ 不限 |

013 魔法筆

用樹枝接力畫畫的遊戲。

1 主持人撿來一根樹枝,並命名為「魔法筆」。
2 只有拿著魔法筆的人才能畫畫。
3 告訴孩子們「大家要全體合力完成一幅畫」,請大家只能畫一點點。
4 主持人先畫,然後把魔法筆交給和自己對到目光的孩子。
5 拿到魔法筆的孩子接著畫畫。
6 最後會畫出什麼誰也無法預料,但這是大家同心協力、一點一滴地完成的畫作。

▶ 請大家都不要說話,可以請還沒輪到的小朋友,想一想前面的人想要畫什麼。
▶ 這是一個可以猜測別人的心思、並想像他們要畫什麼的遊戲,但最重要的是,拿著樹枝在地上畫畫,和大自然有所互動。
▶ 每個孩子只能拿一次魔法棒,這是遊戲的規則。

五感觀察遊戲

「觀察力」在我們的生活中非常重要。唯有具備觀察力才能取得新的資訊,並且以此為基礎進行思考。大自然裡有許多值得觀察的事物,非常適合培養觀察力。除了透過眼睛之外,手和耳朵也可以幫助我們充分地感受大自然。

014 毛毛蟲望遠鏡

用有洞的樹葉觀察世界。

1 請孩子從森林裡找到有破洞的樹葉。

2 請孩子想像自己是吃著樹葉的毛毛蟲,試著從那個洞中觀察世界。

3 將樹葉捲起來做成望眼鏡,用它來觀察周圍的世界。

▶ 要挑選沒有乾枯的樹葉才不容易碎掉。

▶ 請孩子透過有洞的樹葉來看朋友的樣子。如果主持人能拍下這一刻,一定能留下很棒的照片。

▶ 也可以用捲筒衛生的紙芯,或是把紙捲起來來進行這個遊戲。

▶ 也可以玩「毛毛蟲雕刻家」遊戲。毛毛蟲用啃食的方式雕刻葉子,比比看誰能找到更棒的作品。

透過樹葉望遠鏡、捲筒衛生紙芯望遠鏡、瓦楞紙望遠鏡等來觀察四周。
總覺得看出去的世界好像有些不同呢！

| 準備物品 ▶ 有洞的葉子 | 季節 ▶ 不拘 | 地點 ▶ 森林、公園 |
| 人數 ▶ 15 人上下 |

45

015 森林尋寶遊戲

透過尋寶遊戲培養觀察力。

1. 主持人把自然素材藏起來，請孩子找出來的遊戲。
2. 在孩子數到 20 之前，主持人要把自然素材藏在附近，要藏在較明顯的地方。
3. 換找到自然素材的孩子藏寶。

- ▶ 自然素材最好選擇像羽毛或松果這類有明顯特徵的物品，而非普通的樹葉或石頭。
- ▶ 為了防止孩子找錯物品，可以在藏起來之前先用筆或紙膠帶做標示。
- ▶ 可以將遊戲與昆蟲、鳥類或野生動物的保護色特性結合，進行相關的討論和延伸學習。

| 季節 ▶ 不拘 | 地點 ▶ 不拘 | 人數 ▶ 15 人上下 |

016 獨一無二的自然博物館

觀察周遭環境，發現新事物，培養觀察力。

1. 主持人用樹枝圍出方形、五角形等各種形狀的房間。
2. 說明要把房間送給自然裡的朋友，然後把一個自然素材放進房間裡。
3. 接著繼續建造房間，但放入每個房間的自然素材，都不能與其他人放過的重複。
4. 比比看誰建造的、放有自然素材的房間數量最多。

▶ 為了避免選到重複的自然素材，孩子除了要看看其他人已經找到了哪些，也要觀察森林裡還有哪些自然素材，對培養觀察力很有幫助。

▶ 如果人數較多，可以分組進行，看看哪一組能建造出最多的房間。

▶ 完成了很多小房間，整體視覺上會自然形成一幅獨特的畫作，是漂亮的藝術作品。

| 季節 ▶ 不拘 | 地點 ▶ 不拘 | 人數 ▶ 15 人上下 |

017 森林賓果

透過找到指定物品，更具體地觀察森林。

1. 分成兩組。
2. 各組在地上用樹枝排出九宮格。
3. 在各個空格放上事先寫好的物品卡片。
4. 尋找卡片上寫的自然物。
5. 先喊「賓果」的組別獲得勝利。

▸ 重點在於物品卡上寫的內容。可以寫上香菇、苔癬、有刺的樹枝、紅色果實、黃色葉子、有香味的葉子、石頭、動物進食的證據、羽毛等九種自然素材。除此之外，還可以視情況在物品卡上寫「比我矮的樹」、「比我胖的樹」、「比手掌大的樹葉」、「黑色果實」等內容，盡可能讓孩子們多元且具體地感受森林。

▸ 請依照孩子的年齡和程度，決定連幾條線可以「賓果」。

用樹枝排賓果格子時，
遊戲就開始了。

「我找到羽毛了！」

| 準備物品 ▶ 物品卡片 | 季節 ▶ 春天～秋天 | 地點 ▶ 森林、公園 |
| 人數 ▶ 15 人以內 |

018 找出同樣的形狀！

用自然素材玩形狀遊戲，培養觀察力。

1 主持人將繩子的兩端打結放在地上，隨機擺出某個形狀。
2 孩子從周遭找出和繩子形狀類似的自然素材。
3 找到最類似形狀的人出下一道題目。

▶ 也可以使用形狀卡片找類似的自然素材，不過市面上的卡片都是固定的形狀，找到的自然素材也會有限，因此可以自己創作各種形狀的卡片。

▶ 也可以用繩子做出特定的形狀後，玩裝飾遊戲。（例如：用繩子做成魚的形狀，用樹葉裝飾魚鱗。）

可以用繩子圍特定成形狀再來裝飾。

| 準備物品 ▶ 繩子 | 季節 ▶ 不拘 | 地點 ▶ 森林、公園 | 人數 ▶ 15 人以內 |

019 找出同樣的葉子！

找出形狀同樣的葉子，培養觀察力。

1. 主持人從周圍拿起一片葉子。
2. 請大家找出和那片葉子的大小、顏色、形狀等最類似的葉子。
3. 每個人展示自己找到的葉子，主持人選出最像的葉子。
4. 被選出來的人出下一道題目，重複幾次找出各式各樣的葉子。

▶ 也可以用果實取代葉子。
▶ 把大家找來的葉子集中在一起觀察，就可以知道樹葉或果實有很多種類。

| 季節 ▶ 不拘 | 地點 ▶ 森林、公園 | 人數 ▶ 15人以內 |

020 找到不同的葉子！

即使是小小的森林，也有各種不同種類的樹木喔。

1. 分成兩組。
2. 請孩子撿回各式各樣的樹葉。
3. 將準備好的布攤開，請孩子把找到的樹葉放在上面，樹葉不可以重疊。
4. 樹葉種類較多的組別獲得勝利。

▶ 如果包含草的話，種類就太多了，所以只選擇樹葉會比較單純。

▶ 因為孩子並不是分類學家，種類分不清楚也沒關係。重要的是樹葉有各種不同的形狀，不需要完美達到分類學的標準。

| 準備物品 ▶ 布 | | 季節 ▶ 秋天～冬天 | | 地點 ▶ 森林、公園 |
| 人數 ▶ 20 人上下的雙數 |

021 樹葉猜拳

可以更仔細地觀察樹葉。

1 可以在〈找到不同的葉子！〉之後進行。
2 將各組成員從 1 開始編號。
3 主持人指定某種樹葉（例如：葉柄最長的樹葉）。
4 請孩子從組員收集的樹葉中選出一片，藏在背後走出來。
5 大喊「剪刀石頭布！」，「布」的時候一起把樹葉拿出來。
6 確認誰贏了之後，贏的人可以拿走對方的葉子。

▶ 主持人要給予具體的指示。（如：最大的葉子、最小的葉子、葉柄最長的葉子、葉緣的鋸齒最多的葉子等）
▶ 很難分出勝負時算平手，請兩組交換樹葉。
▶ 除了主持人出題之外，如果有孩子想比的項目也可以試試看。

剪刀～石頭～

布！

🍄 |準備物品▶布| |季節▶有很多落葉的秋天| |地點▶森林、公園|
|人數▶雙數|

022 樹葉拼圖

以樹葉拼圖培養觀察力。

1. 請孩子各自撿回一片喜歡的樹葉。
2. 用剪刀把樹葉剪成 3～4 小片。
3. 以組別混合大家的樹葉。
4. 從混合的樹葉中找出自己的樹葉,完成拼圖。
5. 全部的組員先完成拼圖即獲得勝利,也可以換組員玩。

▶ 如果樹葉容易碎掉,就先黏在紙上剪下來做成拼圖。
▶ 剛掉落下來沒多久的葉子很適合用來製作拼圖。
▶ 請配合孩子的年齡調整拼圖的片數。

用剪刀剪樹葉。

終於完成了！

| **準備物品** ▶ 剪刀 | **季節** ▶ 不拘 | **地點** ▶ 森林、公園 | **人數** ▶ 15 人上下 |

023 用手觀察

找出用手記住的物品。

1. 主持人將袋子綁在腰部高度的地方,偷偷在袋子裡放入自然素材。
2. 每個孩子輪流把手伸進袋子裡觸摸物品,然後在森林裡找出同樣的自然素材。
3. 找回物品的孩子圍成一圈,一起數「一、二、三!」,同時把手攤開展示自己找到的自然素材。
4. 主持人也同時揭曉答案,將自然素材從袋子裡拿出來。

- 玩這種遊戲時,如果有人從袋子裡拿出自然素材或說出答案就不好玩了,所以要時時提醒孩子:「能不能偷看?」「不能。」「裡面的東西可以拿出來嗎?」「不行。」「可以說裡面是什麼東西嗎?」「不行。」
- 可以同時掛好幾個袋子,或在同一個袋子裡放好幾個自然素材。
- 可以運用孩子拿回來的自然素材,接著玩其他遊戲。

🍄 |準備物品▶袋子| |季節▶秋天~冬天| |地點▶森林、公園|
|人數▶15人上下|

024 用耳朵觀察

用聲音也能分辨物品。

1. 準備一個紙盒。
2. 偷偷放一個果實在盒子裡,用橡皮筋綁好以免盒蓋打開。
3. 輪流讓孩子搖晃紙盒。
4. 在不打開紙盒的情況下,讓孩子猜猜看裡面放了什麼。
5. 最先準確猜出自然物的人將提出下一個問題。

▶ 建議使用硬挺材質的紙盒。
▶ 不同形狀的果實發出的聲音也不相同,可以引導孩子思考為什麼會有這樣的差異。
▶ 為了讓遊戲順利進行,遊戲前請提醒孩子不要打開盒蓋、不要直接說出答案、不要干擾其他孩子聆聽。
▶ 這個遊戲的前後可以安排一些與聲音相關的活動,例如閉上眼睛傾聽聲音、辨別鳥鳴聲或動物的叫聲等。

橡皮筋

這個感覺很像楊賓呢～

| **準備物品** ▶ 紙盒 | **季節** ▶ 秋天～冬天 | **地點** ▶ 森林、公園 |
| **人數** ▶ 15人以內 |

025 用鼻子觀察

透過嗅覺來感受大自然。

1. 預先摘幾片食茱萸的葉子,揉捏之後放進盒子裡。
2. 讓孩子們排隊,閉上眼睛聞盒子裡的味道。
3. 請孩子到森林裡找出相同氣味的植物。
4. 正確找出植物的孩子可以出下一道題目。

▸ 很多人知道樹木的外觀和名稱,但不知道有什麼味道。透過聞味道和觸摸的經驗,可以更快熟悉大自然。

▸ 如果沒有食茱萸,可以使用山胡椒、魚腥草、艾草,或是具有強烈香氣的花。

▸ 可以和孩子討論植物為什麼會散發氣味。

▸ 遊戲結束後,可以延伸進行嗅覺散步,讓孩子們進一步感受嗅覺的樂趣。

|準備物品 ▶ 紙盒| |季節 ▶ 春天~秋天| |地點 ▶ 有食茱萸的森林|
|人數 ▶ 15 人以內|

026 找出更長的

思考樹木的高度和陽光的關係。

1. 請孩子從自然素材中找出長的物品。
2. 將自然素材放在白布上比較長短,逐步找出最長的物品。
3. 孩子在尋找長的自然素材時,通常會拿樹枝回來。經過幾次之後,就會對樹木的生長產生興趣。
4. 最後,討論樹木為什麼會長這麼高來作結。

▶ 遊戲時,請孩子不能攀折樹枝,只能撿掉在地上的。
▶ 說明樹木的高度與陽光之間的關係,也可以談談為什麼有些樹木比較矮小。
▶ 如果是分組進行的話,也可以將遊戲延伸為組別對抗賽。把每組找回來的自然素材排成一列,比看看哪一組的最長。

| 季節 ▶ 不拘 | 地點 ▶ 健康的森林 | 人數 ▶ 15 人上下 |

027 找出更重的

測重量也是一種觀察力。

1. 主持人準備一個小的自然素材。
2. 請孩子們找出比這個重一點的自然素材。
3. 接著再找出更重一點的自然素材。
4. 最後把所有的自然素材羅列開來,並討論關於重量的問題。

▶ 可以從自己的體重、動物的體重、樹的重量等,延伸到大自然裡的關於重量的話題。(例如:聽說成年老虎有 300 公斤重,那你們要幾個人加起來才能跟老虎一樣重呢?)

▶ 也可以進行「擁抱猜體重」的遊戲,讓孩子們一個接一個抱起朋友來猜測他們的體重,或者將他們依照重量排隊。

| 季節 ▸ 不拘 | 地點 ▸ 不拘 | 人數 ▸ 10 人以內 |

動腦思考遊戲

生活中非常需要思考能力,因為我們總是在思考如何過得更好、如何做出更好的選擇。思考能力包含專注力、創造力、推理能力、邏輯思維等各種能力,其中最重要的就是相信自己、愛自己。

028 該怎麼排序呢?

透過排列樹葉來培養觀察力和分析能力。

1 分組後,讓各組找五片樹葉。
2 請組員根據某個規則將樹葉排列在布上。
3 規則只有組員知道。
4 排列完成後,讓別組猜答案。

▶ 要找出一定的規則,就必須仔細觀察。摸索規則的過程不僅有趣,還能提升思考能力。
▶ 也可以換成果實,或者混合自然素材來進行遊戲。

| 準備物品 ▶ 布 | 季節 ▶ 不拘 | 地點 ▶ 森林、公園 | 人數 ▶ 20人上下 |

029 樹是怎麼長大的？

簡單理解樹木生長的原理。

1. 主持人撿起一個「Y」字形的樹枝。
2. 請孩子去找類似的樹枝。
3. 找回來之後，把最粗大的樹枝放在地上，這代表樹木一歲時的樣子。
4. 接著把細一點的兩個樹枝放在 Y 型的兩端，這代表樹木兩歲時的樣子。
5. 接著把再細一點的四個樹枝放在 Y 型的兩端，這代表樹木三歲時的樣子。
6. 用這樣的方式，逐一把小樹枝連接起來，幫助孩子理解樹木長大的原理。

- ▶ 樹木的生長過程就像是堆積木，從下到上年齡會一層一層增加。這是能讓孩子了解基本生長原理的遊戲。
- ▶ 孩子可以透過這個遊戲，親手觸摸很多樹枝。
- ▶ 孩子在尋找相似樹枝的過程中，有助於提升觀察力。

一歲　　　兩歲　　　三歲

四歲

| 季節 ▶ 不拘 | 地點 ▶ 森林 | 人數 ▶ 不限 |

030 丟松果

培養專注力，同時了解松樹傳播種子的方式。

1. 每人拿著一個松果排隊。
2. 主持人在約三公尺遠的地上用樹枝排成圓圈。
3. 依序把松果丟進圓圈裡。

▶ 要讓孩子們在大自然裡玩得開心並不容易，因為多數在大自然裡進行的遊戲都帶有教育性質，因此我們必須努力讓遊戲更像「遊戲」而不是「上課」。「丟松果」就是一種會讓孩子們想一玩再玩的遊戲。

▶ 如果沒有松果，可以用其他果實或石頭替代。還可以變化玩法，例如閉著眼睛丟、背對著丟等。

▶ 圓圈的大小和距離可以根據孩子的年齡來調整。

▶ 與其以進圈次數來競賽，不如設定得分規則，例如：丟進圓圈得 100 分，碰到樹枝邊緣得 50 分，丟進後又彈出來得 10 分，完全沒進得 0 分，最後累計得分看誰第一名。

▶ 最後可以提醒孩子，種子並不一定會掉到預期的地方，幫助理孩子解自然界的隨機性。

| 季節 ▶ 不拘 | 地點 ▶ 森林、公園、遊戲場等 | 人數 ▶ 15 人以內 |

031 丟葛藤圈

透過投擲藤圈，培養專注力。

1. 將部分葛藤摘下，製作成圈狀。
2. 在附近找一個可作為投擲目標的結構物，例如公園柵欄、空地的柱子等。
3. 分組排隊，朝著目標丟葛藤圈。
4. 丟入最多葛藤圈的組別獲得勝利。

▶ 如果周遭沒有適合作為標的的結構物，孩子們也可以用彼此拋接的方式玩遊戲。

▶ 玩遊戲時可以說明：「葛藤必須攀附其他樹枝才能往上生長，為了能順利攀附其他樹木，藤蔓一定要柔軟才容易彎曲吧？所以才能拿來做這種圈圈。」藉此和孩子們一起討論森林裡動植物之間的關係。

▶ 也可以使用其他藤本植物代替。

丟到樹枝上。

彼此拋接。

耶！

| 季節 ▶ 春天～夏天 | 地點 ▶ 森林、公園等 | 人數 ▶ 雙數 |

032 堆石塔

用石頭小心翼翼的堆成塔,培養專注力。

1. 在石頭很多的地方進行。
2. 分成兩組。
3. 在指定的時間內,比賽哪一組堆的石塔較高。

▶ 堆石塔可以有多種玩法,例如:每組輪流派一位組員出來放一顆石頭,塔先塌下來的話,那組就輸了;或是,放一片樹葉再放一顆石頭,然後再放樹葉、再放石頭,如此重複,抽出樹葉時如果石塔倒塌,該組就輸了。

▶ 堆好石塔後,也可以玩從遠處擊垮石塔的遊戲,但由於丟擲石頭有可能導致受傷,因此要保持安全距離。

▶ 森林裡的松果或樹枝等有點硬度的物品,都可以拿來玩堆疊的遊戲。

▶ 也可以請孩子在樹幹上卡入小樹枝,發揮自己的藝術創意,將其變成堆石塔的延伸遊戲。

033 找到樹枝的平衡

用樹枝的平衡培養專注力。

1. 每個人撿一根長約 60 ～ 100 公分的樹枝。
2. 將樹枝水平放置在森林中可以看到的凸出的樹幹或樹枝上,試著保持平衡。
3. 如果沒有適合的樹,可以兩人一組進行遊戲。一人將樹枝豎起像拐杖般握住,另一人將樹枝平放在上面,保持平衡形成「T」字形。

▶ 孩子們通常在森林撿起樹枝就會立刻當成劍來對打,這麼做很容易受傷。與其奪走樹枝,不如提議進行能用樹枝來玩的安全遊戲。

▶ 「T字形平衡」只是一種基本玩法,還可以繼續延伸,例如,在上面再放其他樹枝或石頭,或者試著在保持平衡的情況下,將手中的樹枝移動到其他地方,嘗試更多樣的平衡挑戰。

▶ 在進行了各種平衡遊戲後,還可以將其延伸為製作懸掛裝飾的手作活動,增添創意趣味。

來，我要放手了～

各種平衡遊戲

多人合作的平衡遊戲

| **準備物品** ▸ 樹枝 | **季節** ▸ 不拘 | **地點** ▸ 森林、公園等 |
| **人數** ▸ 15人上下 |

85

034 楓樹種子飛行

讓楓樹的種子飛得遠遠的,同時想一想各種傳播方式。

1. 請每人撿回或摘下一顆楓樹種子。
2. 主持人在地上畫直徑約 30 公分的圓圈。
3. 請孩子們將種子拿至高於自己眼睛的位置後,放開種子讓它自然地掉落到圓圈裡。(通常種子會隨風飄走,要掉入圓圈裡其實沒那麼容易。)

- 很多人認為楓樹種子會以「人字型」掉落下來,但其實它會分成兩半,然後各自飛落。玩遊戲前向孩子們說明這件事,讓他們先分成一半再玩。
- 可以在遊戲進行時,向孩子們講解種子的傳播方式。
- 完成種子落入圓圈的遊戲後,可以比賽誰能將種子拋得更遠。
- 也可以使用像臭椿這種有翅果的種子。如果沒有楓樹或臭椿種子的話,就用樹葉玩。

楓樹種子

飛遠一點吧！

🍄 |**準備物品**▸楓樹種子| |**季節**▸秋天| |**地點**▸森林、公園等|
|**人數**▸15人以內|

87

035 將種子傳播得更遠

透過遊戲思考種子的形狀對其傳播方式有什麼影響。

1. 請主持人準備一根大樹幹和長度約 50 公分的細棍。
2. 請孩子們各自找一根樹枝。
3. 把找回來的樹枝橫放在樹幹上。
4. 每個孩子輪流用主持人的細棍，用力打自己橫放在樹幹上的樹枝，讓它飛遠。
5. 看看誰能讓樹枝飛得最遠，然後討論為什麼。

- ▶ 孩子們找回來的樹枝大小和形狀都不一樣。可以藉此討論植物是如何依賴種子大小和形狀的特性，努力將種子傳播到更遠的地方。
- ▶ 對於年紀太小不太能打中的孩子，可以挖洞放小樹枝，讓他們用大樹枝用力將小樹枝挑起來，看看能挑多遠。
- ▶ 用樹枝玩遊戲很容易受傷，需提醒孩子注意安全，避免發生意外。

嘿！

可以在地上挖洞放上小樹枝，再用大樹枝挑起來，看看能挑多遠。

| **準備物品** ▶ 樹枝 | **季節** ▶ 不拘 | **地點** ▶ 不拘 | **人數** ▶ 20 人以內 |

036 創作昆蟲

透過遊戲認識昆蟲的身體構造。

1 準備一顆骰子（如果沒有，可用橡實或松果替代）。
2 在地上畫一個圓。
3 擲骰子或拋松果（例如：投擲六個松果，看進入圓圈的數量有幾個），根據出現的數字開始畫昆蟲。
4 分成兩組比賽，看哪一組最快完成昆蟲。
5 擲出的數字對應一個身體部位。一：嘴巴／二：觸角／三：頭、胸、腹／四：翅膀／五：3個單眼、2個複眼／六：腳。
6 用石頭、樹枝、果實、樹葉等代替昆蟲的各個部位，在地上組成昆蟲的圖案。

▶ 如果用自然素材不容易裝飾，直接在地上畫昆蟲。
▶ 可以在遊戲過程中解說昆蟲的身體構造，並延伸討論昆蟲與蜘蛛的差異等。

骰子點數	對應部位
1	嘴巴
2	觸角
3	頭、胸、腹
4	翅膀
5	3個單眼、2個複眼
6	腳

可以用松果替代骰子。

標示:樹皮、松針、果實、樹葉、樹枝、石頭

| 準備物品 ▶ 骰子 | 季節 ▶ 不拘 | 地點 ▶ 不拘 | 人數 ▶ 20 人以內 |

037 找出昆蟲

透過保護色遊戲，了解昆蟲的生存方式。

1. 準備紙和筆，請每個人畫昆蟲。
2. 利用自然素材裝飾昆蟲，並幫它取名字。
3. 用剪刀把昆蟲剪下來，藏在附近的某個地方。
4. 找出別人藏起來的昆蟲，然後討論誰的昆蟲為什麼最晚被發現。

▶ 也可以分成兩組互找藏起來的昆蟲。請孩子把裝飾的昆蟲放在大自然的某處，但不要埋在地下或藏在很隱密的地方。

▶ 讓孩子了解實際上昆蟲會待在樹皮、泥土、樹葉等，周遭環境和自己的顏色類似的地方，以便不被敵人發現。

▶ 可以舉例除了昆蟲之外，也有很多動物有保護色。

| **準備物品** ▶ 紙、筆、膠水 | **季節** ▶ 不拘 | **地點** ▶ 不拘 |
| **人數** ▶ 20 人以內 |

038 找出杜鵑鳥的蛋

透過遊戲了解杜鵑鳥的生態,並培養觀察力。

1. 用樹枝製作一個鳥巢後,開始遊戲。
2. 分成兩組。
3. 透過猜拳決定角色,贏的組別為「杜鵑鳥組」,另一組則為「大葦鶯組」。
4. 大葦鶯組在鳥巢裡放入稱為「蛋」的自然素材。
5. 大葦鶯組轉過身去數到 20 之前,杜鵑鳥組要拿出其中一個蛋,然後換成另外一個自然素材。
6. 大葦鶯組要找出被杜鵑鳥組換掉的蛋。

▶ 請先築好鳥巢之後再玩遊戲。
▶ 可以討論為什麼杜鵑鳥不築巢,而是將蛋偷偷產在大葦鶯、棕頭鴉雀、黃尾鴝等其他鳥類的鳥巢中。
▶ 可兩組互換,多進行幾次遊戲,觀察用哪一種自然素材來當蛋比較難被辨識出來。

用樹枝築巢。　　　　　在巢裡放蛋（自然素材）。

嘻嘻～
你應該猜不到！

調換了
哪一個呢？

| 季節 ▸ 不拘 | 地點 ▸ 不拘 | 人數 ▸ 20人以內 |

039 製土

了解因為許多動物的幫忙才能讓泥土變健康。

1. 在累積落葉的地方玩遊戲。
2. 撿起最上方的一片樹葉放在布上。
3. 將最上層的落葉移開,撿起下一層的一片樹葉放在布上。用這種方式漸漸往下,把越下方(越舊)的落葉依序放在布上。
4. 討論是哪些生物將落葉漸漸分解成小碎片。
5. 鼓勵孩子們一起試試:「我們也把落葉變成小碎片吧!」然後用手把樹葉弄成碎片。

▶ 跟孩子分享,多虧平常有這些不起眼的甲蟲、鼠婦、蚯蚓等動物,森林的土壤才能變得更加肥沃。
▶ 可以用撕碎的樹葉創作馬賽克拼貼畫。
▶ 遊戲也可以用剪刀剪落葉來進行,但須注意使用安全。

過了一段時間後樹葉會漸漸被分解。

哇！葉子碎掉了，我有種變成鼠婦的感覺！

可以用樹葉碎片創作馬賽克拼貼畫。

| 季節 ▶ 不拘 | 地點 ▶ 不拘 | 人數 ▶ 20 人以內 |

融入自然遊戲

學習或認識大自然是很棒的事情,但用全身來感受、親近大自然更好。因此,我們需要不斷地接觸大自然並擁抱它,把大自然當成是自己的朋友,甚至把自己直接變成其中的一部分,都可以讓我們更貼近大自然,進一步了解大自然的生物為什麼是這樣的型態、以及它為什麼選擇了這樣的生存方式。

040 找到舒服的地方

快速親近森林,並創造難忘的美好回憶。

1 請每個孩子在森林中選擇一個自己喜歡的地方。
2 到達選定的地點後,閉上眼睛靜靜地待 5 分鐘。
3 請孩子分享自己當下的感受和體驗。

▶ 如果不想直接坐或躺在地上、落葉上,可以使用野餐墊或坐墊。

▶ 不一定要閉上眼睛,只是靜靜地坐著也很棒。事實上,只要進入大自然,我們的身心就會感到放鬆。

找到自己喜歡的地方暫時停留。

| **準備物品** ▸ 野餐墊、坐墊 | **季節** ▸ 不拘 | **地點** ▸ 森林 |
| **人數** ▸ 15 人以內 |

041 介紹我的朋友

和樹做好朋友留下紀念。

1. 請大家各自從森林裡挑選一棵樹作為「樹朋友」。
2. 為「樹朋友」取一個名字。
3. 將取好的名字寫在紙膠帶上並貼在樹上（主持人可以攜帶紙膠帶和簽字筆，協助孩子們寫下來。）
4. 請孩子們在森林裡奔跑找尋別人的樹名，試著記住其他人的「樹朋友」的名字。
5. 最後詢問大家記住了多少個名字，並請他們回答。

▶ 遊戲結束後，請孩子們親自將自己寫下的「樹朋友」名字的紙膠帶，從樹上撕下來。

▶ 也可以不貼名字，改成聆聽孩子們逐一介紹自己的「樹朋友」。

▶ 也可以把遊戲變成鬼抓人，看看大家記住多少「樹朋友」的名字。當鬼的人說一個樹的名字，大家全都跑向那棵樹，鬼要抓最後到達的人，換被抓的人當鬼。

| **準備物品** ▶ 紙膠帶、簽字筆 | **季節** ▶ 不拘 | **地點** ▶ 森林 |
| **人數** ▶ 15 人以內 |

042 寫給樹的一封信

透過寫信給樹，和樹木進行更親近的交流。

1. 撿拾一片樹葉當作信紙。
2. 找一棵「樹朋友」當成寫信的對象。
3. 用簽字筆把想要說的話寫在樹葉上。
4. 如果附近有像刺槐一樣有刺的樹，可以折下一個刺，將信刺在樹皮上。

- ▶ 樹皮通常像海綿一樣柔軟，因此很容易刺進去。如果沒有長刺的樹木，也可以用細小的樹枝替代。
- ▶ 建議選刺槐、栓皮櫟、松樹等樹皮較厚實的樹。
- ▶ 當建議找寬大又硬挺的葉子來當信紙，例如槲櫟或日本玉蘭的葉片。
- ▶ 請孩子帶著「相信樹一定能感受到自己心意」的想法，寫信給樹。

把刺折下來。

在樹葉上寫信。

我要釘在樹上。

| **準備物品** ▶ 油性筆或簽字筆 | **季節** ▶ 不拘 | **地點** ▶ 森林裡 |
| **人數** ▶ 15 人以內 |

043 找出胖胖的樹

抱樹幹並猜測樹齡。

1. 讓大家抱抱看好朋友或主持人。
2. 記得抱住的感覺後,到森林裡找出一棵粗細相似的樹木。
3. 請孩子們各自猜測那棵樹的樹齡。

▶ 不能為了看年輪而砍樹,因此用推測的。針葉樹大約一年長一個枝節,因此數樹枝就能大約得知樹齡。對於不會每年長枝節的樹,通常可以用樹幹的粗細來推測,直徑 20 公分的樹大約就是 20 歲。

▶ 這個遊戲看似是在推測樹齡,其實重點是讓孩子實際擁抱並感受樹木。

| 季節 ▶ 不拘 | 地點 ▶ 森林 | 人數 ▶ 15人以內 |

044 這是我的巢！

透過玩樹枝來感受土地。

1. 請每個人從周圍撿大約 20 公分的樹枝。
2. 兩人一組。
3. 主持人在地上畫直徑約 30 公分的圓，請兩人把自己的樹枝放在裡面。
4. 進行猜拳，贏的人先彈或拍打自己的樹枝，將對方的樹枝推出圓外。
5. 雙方輪流進行，直到其中一根樹枝完全被推出圓圈。

- ▶ 這個遊戲象徵森林裡搶奪啄木鳥巢的鳥類，同時也鼓勵孩子們觸摸樹枝和土壤。
- ▶ 樹枝的長短、圓圈的大小、樹枝要「完全離開圓圈」還是「一半超出圓圈」才算輸等詳細規則，可以依照現場的情況調整。
- ▶ 也可以贏的人跟贏的人、輸的人跟輸的人一組繼續遊戲，分出最後的冠軍。

|季節 ▶ 不拘| |地點 ▶ 不拘| |人數 ▶ 雙數|

045 颱風來了！

透過擁抱樹木，增進對自然的親近感。

1. 挑選幾棵不同種類的樹，並用紙膠帶做記號。樹的數量請依據參與人數來調整。（如：10人就選8棵樹）
2. 選出一個人當鬼，稱他為「颱風」。
3. 主持人喊「颱風來了！」時，其他孩子就要跑去抱有標示的樹，這時「颱風」就要去抓沒有抱樹的人。
4. 沒有抱樹的人如果去抱了已被其他人抱住的樹，原先抱住這棵樹的人就要跑去抱別的樹。

▶ 有的孩子為了當鬼故意被抓到，所以要給當鬼的人簡單的懲罰。懲罰要經過大家共同決定和同意，建議是類似「抱著一棵樹唱歌」這種可以接觸大自然的懲罰。

▶ 孩子們從這棵樹移動到那棵樹的過程中，可以感受到不同樹木的觸感。此遊戲適合在穿著長袖衣服的季節進行，以減少不必要的摩擦或刮傷。

| **準備物品** ▸ 紙膠帶 | **季節** ▸ 秋天~冬天 | **地點** ▸ 森林裡 |
| **人數** ▸ 15 人以內 |

046 如果我是鳥

一起變身為鳥兒，築一個屬於自己的獨特鳥巢吧！

1. 請大家想像自己變成了一隻鳥。
2. 想一想如果自己是鳥，會築什麼樣的鳥巢。
3. 利用枯枝、落葉、草或石頭等自然素材，打造屬於自己的巢穴。
4. 欣賞彼此的鳥巢，分享築巢的過程和想法。

▶ 沒有指定要變成什麼鳥，每個人都可以自由發揮，根據自己的想像來決定巢穴的地點、大小、材料等，盡情發揮創意。

▶ 如果有人不知道該怎麼築巢，可以到喜鵲巢附近觀察及模擬，就可以了解築喜鵲巢沒有那麼容易。

▶ 也可以分組一起築一個大型的巢，進一步體驗合作的樂趣。

| 季節 ▶ 不拘 | 地點 ▶ 樹枝很多的森林 | 人數 ▶ 20 人上下 |

047 趴低一點！

化身為貼地生長的蓮座狀植物，學習它們如何生存。

1. 準備一條繩子，由兩人各握住繩子的兩端，這條繩子象徵寒冷的「冬風」。
2. 其他孩子都是「植物」，需要趴在地面上，避開頭上來回晃動的繩子才能活下來。
3. 因為植物的根是緊緊扎在地上，所以不能跳起來躲避繩子。
4. 持續進行，活到最後的植物獲得勝利。

▸ 月見草、薺菜、黃鵪菜等蓮座狀植物，在冬天會把葉子整個打開平貼在地面上，抵抗寒冷。牠們以低姿態度過寒冬，在春天比任何植物更快綻放花朵，甚至能多綻放一兩次。

▸ 逐漸降低繩子的高度，可以讓遊戲更有趣、更具挑戰性。

▸ 在森林裡也可用藤蔓或長樹枝取代繩子。

| **準備物品** ▶ 繩子 | **季節** ▶ 冬天～春天 | **地點** ▶ 森林或公園的土地 |
| **人數** ▶ 20 人以內 |

115

048 浣熊在哪裡？

透過在森林捉迷藏，了解野生動物的生活。

1. 請在樹木茂密的地方進行遊戲。
2. 猜拳，輸的人當「獵人」，其餘人當「浣熊」。
3. 獵人站在固定的一棵樹前，靠在樹上閉眼數到 20。這時浣熊們要在森林中找地方躲藏。
4. 獵人數完就開始找浣熊，但身體不可以離開樹，獵人的手或腳必須靠在樹上，從各個角度試著找出浣熊。
5. 被獵人看到的浣熊就出局，看看誰能留到最後不被發現。

▶ 討論適合讓野生動物安心生活的森林，應該要具備哪些條件。

▶ 討論增加獵人的數量後，可能會發生什麼變化或影響。

▶ 如果獵人完全找不到浣熊，可以移動到另一棵樹進行遊戲。移動時要先大喊：「我找不到浣熊！」，然後重新數到 20 後再找，浣熊們可以趁這個時候再次換位置躲藏。

| **季節** ▸ 不拘 | **地點** ▸ 樹木密集的森林 | **人數** ▸ 10人上下 |

049 多長一歲

體驗樹如何艱難的成長一歲。

1 從身邊挑選一棵樹，和大家一起猜測它的年齡。
2 請大家依據猜測的樹齡，在樹的周圍畫出年輪。
3 先選出一個人，請他一手扶著樹，另一手拿著樹枝在地上繞著樹畫一圈，代表一歲。
4 再找另一個人牽前面的人的手，用樹枝畫出更大的圓，代表兩歲。
5 以此方式依序進行，直到大家畫完為止。

▶ 第一個人的手不能離開樹，其他人如果把牽住的手鬆開，也算失敗。

▶ 在樹的周圍畫一個年輪都這麼不容易了，那麼樹木增長一歲究竟有多麼困難呢？想像一下，樹木每年都要克服艱難的環境才能迎接一年又一年的生長，感受那份強大的生命力。

▶ 可準備年輪清晰的木片，解說年輪的意義與樹木的成長故事。

| 季節 ▶ 不拘 | 地點 ▶ 不拘 | 人數 ▶ 20人以內 |

050 光合作用猜拳

透過遊戲理解光合作用的原理，同時體驗擁抱樹木的樂趣。

1 將「剪刀」代表二氧化碳，「石頭」代表水，「布」代表陽光。

2 三個人一組，進行猜拳。

3 如果三個人分別出了「剪刀」、「石頭」和「布」，表示光合作用成功。如果沒有成功，就要重新和其他人組隊，再次進行猜拳。

4 請成功完成光合作用的人前往事先指定的樹並擁抱它，替樹木行光合作用，使它更加茁壯。

5 最後未能完成光合作用的人，需接受小小懲罰。

▶ 此遊戲的重點不在於誰在猜拳遊戲中獲勝，而是要三個人各自出不一樣的拳，才能完成光合作用。

▶ 猜拳一次沒有成功，就請孩子立刻與其他人重新組隊並繼續猜拳，增加孩子們的互動機會。

▶ 用擁抱樹木象徵替樹帶來行光合作用的生長力量，透過遊戲不僅能增進對光合作用的理解，更能讓孩子們與樹木親近。

「剪刀」是二氧化碳！

「石頭」是水

「布」是陽光

三者兼具，光合作用就成功了！

成功了！

| 季節 ▶ 不拘 | 地點 ▶ 森林、公園 | 人數 ▶ 3 的倍數 |

121

051 森林猜拳

觸摸自然素材刺激觸覺。

1. 用自然素材取代手玩猜拳的遊戲（樹枝是「剪刀」、石頭是「石頭」、葉子是「布」）。
2. 請孩子們各自找出三種自然素材作為遊戲道具。
3. 兩人一組，各自選擇出示一種自然素材，以此進行猜拳。
4. 贏的人可以拿走輸的人的天然素材。

- ▶ 遊戲可玩到最後產生一位最終勝利者，但若時間不足，也可以提前結束，贏得最多自然素材的人獲勝。
- ▶ 遊戲結束後，將所有收集的自然素材放在布上，讓孩子們辨認哪些是自己找到的。
- ▶ 也可以用刺槐的果莢進行延伸遊戲，比較從地上撿到的果莢中的種子數量，多的人就贏了。
- ▶ 此遊戲不僅能讓孩子在遊戲中探索和感受自然素材，也能增進他們對大自然的細膩觀察力。

樹枝是「剪刀」

石頭是「石頭」

樹葉是「布」

剪刀石頭布！

＝4

可以比較刺槐果莢中的種子數量來決定勝負。

| 季節 ▶ 不拘 | 地點 ▶ 森林、公園 | 人數 ▶ 雙數 |

發洩精力遊戲

孩子就是要盡情地奔跑和玩耍。孩子也有自己的壓力，雖然使用手機或電腦玩遊戲可以得到一些樂趣，但無法紓解最根本的壓力。這時候，如果能讓他們到戶外盡情地跑跳玩耍，心情就會改善許多。既然都來到大自然了，就放下學習的壓力，讓自己充滿活力地自由玩耍吧！

052 高一點、再高一點

比前一個人再跳高一點的遊戲。

1. 適合在森林裡找到很會跳的蚱蜢等昆蟲後玩的趣味遊戲。
2. 對孩子們說：「我們也像蚱蜢一樣跳得高高的吧！」，然後請大家圍成一圈站好。
3. 第一個人先跳，接著旁邊的人必須跳得比他更高一點。
4. 如果沒有跳得更高，就要接受簡單的懲罰，然後從那個人重新開始。
5. 分享跳高的感覺。

▶ 可將孩子分組，看看哪一組能全員都順利完成從頭到尾越跳越高的挑戰。這樣的遊戲能培養組內成員的互相體諒與觀察的能力。

▶ 也可以把跳高改成有趣的拋接松果遊戲。這樣的遊戲能幫助孩子提升專注力與培養關懷他人的心意。

嘿！

他跳太高了！

也可以玩丟松果。

他丟很高的話，我會有點吃力呢…

我要更高一點～

| 季節 ▶ 不拘 | 地點 ▶ 不拘 | 人數 ▶ 不限 |

127

053 春天冬天青蛙跳

在初春時，讓活力下降的孩子們跳起來的遊戲。

1. 讓孩子們蹲在起點上，請大家用青蛙跳跳到遠處的終點（池塘）。
2. 選出兩個孩子分別扮演「春天」和「冬天」，其餘的人都是「青蛙」。
3. 主持人喊「出發！」時，青蛙們就要跳出去。如果被「冬天」碰到就要停止跳躍，被「春天」碰到就可以重新跳躍。
4. 先抵達池塘的人獲得勝利，但輸贏並不是這個遊戲的重點。

▶ 建議扮演「春天」和「冬天」的孩子，在碰到青蛙時要大聲喊出「春天」和「冬天」，這樣青蛙們在停止或重新跳躍時才不會混淆。

▶ 到池塘的距離，請依情況自行調整。

▶ 遊戲結束後，可以和孩子們討論青蛙的生態。

| 季節 ▶ 初春 | 地點 ▶ 森林空曠的草地、草皮 | 人數 ▶ 不限 |

054 腳不落地

透過遊戲，思考為什麼都市需要森林。

1. 利用樹樁、石頭、樹幹等自然素材，做出踏腳石。
2. 走過踏腳石時，腳落地就算出局。出局的人需回到隊伍的最後面重新開始。
3. 每次減少一塊「踏腳石」，增加遊戲難度。

- 都市中的森林對許多生物來說，就像連接的踏腳石。森林和森林彼此相連時，野生動物才容易移動、遷徙，鳥類也能中途停留休息。分布在都市各處的公園，正是扮演著連結生態圈的踏腳石角色。
- 請確保每個踏腳石穩固，以防孩子跌倒或受傷。
- 請孩子小心謹慎地走過踏腳石，慢慢移動完成挑戰。這不是比速度的遊戲。

| 季節 ▶ 不拘 | 地點 ▶ 森林 | 人數 ▶ 不限 |

055 綠色踏腳石橋

透過放置踏腳石，了解生態系統。

1 分成兩組，請各組選出一名「放踏腳石的人」。指定起點和終點，將中間稱為「河」。

2 各組給兩顆石頭，作為搭建通往終點的踏腳石。

3 只有「放踏腳石的人」才能移動石頭。

4 各組依照順序踩踏腳石過河，如果沒踩穩石頭而「掉入河裡」，就出局了。

5 最快將組員送到河對岸的隊伍獲勝。

▶ 可以用寬大的樹葉或木塊取代石頭。

▶ 雖然石頭的數量相同，但各組可以選擇不同的過河策略。

▶ 依照實際情況，可以增加石頭的數量以調整遊戲難度。

| 季節 ▶ 不拘 | 地點 ▶ 不拘 | 人數 ▶ 20 人以內 |

056 接力跳遠

透過接力跳遠的遊戲,思考冬芽的成長過程。

1. 分成兩組,並為每組成員從 1 開始編號。
2. 每組的 1 號站在起點上,猜拳,贏的人先跳,在著地點放置一根小樹枝作為標記。
3. 1 號跳得比較遠的組別可先開始,換 2 號從 1 號放置的樹枝位置起跳。
4. 用這種方式依此類推,直到最後一個人跳完。
5. 確認哪一組跳得比較遠,並一起討論為什麼。

▶ 在森林裡觀察樹木時,可以發現每顆樹的長度都不同。就算是同樣的樹,樹枝的長度也不一樣。降水量、溫度、蟲害、養分等,各種因素造成了不同的結果。人的成長也會受各種因素影響,哪些因素對我們的成長有益呢?是閱讀、遊戲還是學習?大家可以一起想想看。

▶ 須提醒孩子,跳遠是紀錄「腳著地的位置」,而不是手撐地的位置,跳躍時請小心。

| 季節 ▶ 不拘 | 地點 ▶ 森林、公園 | 人數 ▶ 雙數 |

057 樹為什麼會死？

了解又大又壯的樹木，最終也會死亡的原因。

1. 從孩子中選出一名當「天牛」，其他孩子是「樹」。
2. 一群「樹」要站在兩棵大樹之間，在後方鋪一塊布，上面放一個自然素材。
3. 「天牛」要穿過「樹」，把自然素材拿回來。
4. 「樹」彼此手牽手，要阻止「天牛」闖進來，但不能對「天牛」拳打腳踢。

▶ 在地球上最大、最重、活最久的生物就是樹。不過樹通常會因為小型昆蟲的侵害、生病、或被真菌入侵而死掉。死掉的樹木會為小樹讓出空間，並且在死亡後仍為許多動物提供養分、棲息處和庇護所，繼續對生態系統作出貢獻。

▶ 可以增加多個「天牛」，觀察遊戲會有什麼變化。

▶ 如果人數很多，也可以讓「樹」圍圓圈站立，讓「天牛」站在中間，增添遊戲的趣味性與挑戰性。

| 季節 ▶ 不拘 | 地點 ▶ 不拘 | 人數 ▶ 不限 |

058 吊樹木單槓

培養臂力，也學習樹木留下健康果實的生存方式。

1. 挑選樹枝較低的樹木。
2. 請孩子吊在樹枝上。
3. 吊掛最久的人獲得勝利。
4. 說明樹木為了讓有限的養分集中供應給健康且有潛力成熟的果實，會自然地淘汰掉部分弱小或過多的果實。

▶ 暴風雨過後，樹上的果實會大量掉落。這是因為樹木為了集中養分培育健康的果實，選擇讓較弱的果實自然脫落。

▶ 如果沒有適合吊掛的樹枝，也可以在兩棵樹之間綁繩子作為替代。

▶ 可以進行最終優勝者的競賽，或者玩「限時挑戰」的吊掛挑戰，增添趣味與競技性。

| **季節** ▶ 不拘 | **地點** ▶ 有樹的地方 | **人數** ▶ 不限 |

059 接力踢松果

開心的踢著松果玩。

1. 分成兩組,並為每組成員從 1 開始編號。
2. 各組給一顆又大又漂亮的松果。
3. 各組的 1 號站在起點上,聽到信號就將手上的松果鬆開並用力踢出。
4. 2 號從 1 號踢落松果停下的地方接力踢松果,最後的人踢完,由 1 號重新開始踢松果。
5. 在遠處設定一個折返點或目標物,先回到起點的組別獲得勝利。

▶ 折返點太近就不好玩了。建議設定較遠的距離,讓隊伍需要多踢幾次松果才能完成。

▶ 可以把松果直接放在地上踢,如果先拋起再踢,會飛得更遠、更好玩。

| **準備物品 ▶ 松果** | **季節 ▶ 不拘** | **地點 ▶ 不拘** | **人數 ▶ 20 人上下** |

060 越小越好

透過遊戲了解昆蟲如何運用其小巧的身體來生存。

1. 用大石頭堆成石塔。
2. 讓孩子各自撿一個石頭,站在距石塔約三公尺遠處以組別排隊。
3. 把石頭丟出去,打中最大的石頭是 10 分,打中中間的石頭是 50 分,打中最小的石頭是 100 分。
4. 各隊依順序輪流丟一次,最後將分數加總,分數高的組別獲得勝利。

▶ 昆蟲之所以是地球上最繁盛的動物之一,得歸功於牠們小巧的身軀。不僅不容易被天敵發現、容易躲藏,且維持生命所需的能量也較少。因此,我們不能因為昆蟲體型很小就輕視牠們,要從中領悟到「小即是美」的人生智慧。

▶ 也可以玩丟樹枝的遊戲。在樹樁上放松果或石頭,丟擲樹枝來擊中目標。但需注意安全,投擲區域務必淨空,以免發生意外。

| **季節** ▶ 不拘 | | **地點** ▶ 森林、公園、空地 | | **人數** ▶ 20 人以內 |

061 許願

透過投擲松果來釋放壓力,並許下心願。

1. 請孩子各自撿一個松果。
2. 主持人事先找到一棵樹枝呈「Y」字形分叉的樹,請大家站在樹前。
3. 在離約五公尺遠的地方,將松果丟向樹枝分叉中間。
4. 請孩子在心裡許願再丟松果。說明松果如果穿越樹枝中間的分叉,願望就會實現。

▶ 不必擔心沒有丟成功的孩子會感到失望,因為孩子會持續玩到成功穿越樹枝的分叉為止,已經丟成功的孩子也會一直重複玩。

▶ 也可以用小木塊取代松果。石頭有可能造成樹木受傷,因此不建議使用。

| 季節 ▶ 不拘 | 地點 ▶ 森林、公園、空地 | 人數 ▶ 20 人以內 |

062 丟遠

透過用力投擲自然素材，釋放壓力並享受樂趣。

1. 請孩子撿石頭、樹枝、松果等任何一個自然素材。
2. 兩人一組，先觀察對方的自然素材。
3. 猜拳，贏的人先用力把自己的自然素材丟出去。
4. 輸的人要把贏的人丟出去的自然素材找回來。找回來就換輸的人丟，若找不到，就由贏的人再找另一個自然素材丟出去。

▶ 用力投擲的遊戲要在周圍沒有人時才能進行，要提醒孩子注意安全。

▶ 不一定要把自然素材丟得很遠，也可以丟進有許多相似物的地方。例如，把松果丟到有很多松果的地方，遊戲就會變得很有挑戰性。

| 季節 ▶ 不拘 | 地點 ▶ 森林、公園、空地 | 人數 ▶ 20 人以內 |

063 爬樹

爬到樹上自然會和樹變得更親近。

1. 主持人挑選一棵容易爬的樹。
2. 孩子們一個一個輪流，小心謹慎地爬上樹木。
3. 告知幾個規則和注意事項，確保大家都能夠安全地爬樹。

▶ 挑選一棵好爬的樹是關鍵。要選擇樹幹粗壯、枝幹從底部開始分岔的樹，方便孩子攀爬。樹木的周圍最好有泥土或落葉覆蓋，以減輕不慎摔落時的傷害。

▶ 爬樹規則：
- 只能攀爬主持人指定的樹木。
- 只能在主持人的注視下爬樹。
- 禁止嬉鬧。
- 不可以因為貪心或想出鋒頭而爬很高。
- 如果在攀爬或爬下樹木時遇到困難，應立刻向主持人尋求幫助。

| 季節 ▶ 不拘 | 地點 ▶ 有樹的地方 | 人數 ▶ 20人上下 |

團隊合作遊戲

大自然中的眾多生物彼此依存、互相幫助，我們也無法脫離自然獨立存在，需要彼此扶持、相互合作。既然都來到大自然裡了，大家就一起齊心合力克服困難的挑戰，讓遊戲變得更好玩吧！

064 浣熊大便

扮演浣熊，體驗排出果實便便的樂趣吧！

1. 每個孩子都是「浣熊」，請他們各自去尋找可以作為遊戲中「果實」的自然素材，例如掉落的果實、石頭或樹枝。

2. 在距離起點約 20 公尺處，用樹枝圍出一個方形區域，並稱之為「浣熊廁所」。

3. 告訴孩子們，浣熊剛剛吃了美味的果實，現在果實在肚子裡經過消化，變成便便準備排出。

4. 主持人大喊「出發！」，浣熊就要把果實夾在膝蓋中間，跑到廁所讓果實掉落。如果中途掉落果實，就要回到隊伍最後面重新來過。

5. 遊戲結束後，用地上的樹枝和果實排成一棵樹。

▶ 可以分組玩接力賽。

▶ 將果實改夾在兩人的屁股中間，遊戲會變得更好玩。

▶ 雖然這是一個分組競賽，看哪組浣熊能在廁所留下最多便便，但最終大家會齊心協力，共同完成一棵大樹。

用浣熊廁所和大便完成一棵樹！

| 季節 ▶ 不拘 | 地點 ▶ 森林、公園、空地等 | 人數 ▶ 20人以內 |

065 自然素材接力賽

以接力自然素材的方式,培養溝通能力及合作精神。

1 分成兩組。
2 每一組給一片樹葉。
3 每組派兩人出來,兩人用手指輕輕夾住樹葉,沿著指定路線走到折返點再回來,保持合作不讓樹葉掉落。
4 換下一組隊員接過樹葉繼續接力,先回來的組別獲得勝利。

▶ 如果樹葉在中途掉落,就在原地調整好樹葉再繼續出發。
▶ 也可以用松果、樹枝取代樹葉。
▶ 除了手指,也可以用肩膀、背、額頭、屁股等其他身體部位進行遊戲。
▶ 也可以團體形式進行遊戲,讓整個小組一起同時移動。

一二~

小心一點，快掉下來了~

用身體的各個部位接力。

用各種自然素材接力。

| 季節 ▶ 不拘 | 地點 ▶ 不拘 | 人數 ▶ 20人上下 |

066 立樹

透過豎起樹木培養合作精神，同時了解樹根的作用。

1 分成兩組，請各組撿一些樹枝。
2 請各組把最長的一根樹枝垂直立起。
3 其他樹枝用來支撐中間的樹枝，不能讓它倒下來。如何穩固搭建支撐架是遊戲的關鍵。

▶ 再高大的樹木，如果沒有樹根就不能站立。樹根雖然長在地下眼睛看不到，但它們默默地承擔著重要的工作，我們也要像樹根一樣，貢獻出自己的力量。

▶ 在這類需要合作的遊戲中，過程比結果更重要。就算孩子不斷失敗或感到困難，也不要直接給予提示，讓孩子們透過討論和嘗試找到解決方案。

| 季節 ▶ 不拘 | | 地點 ▶ 森林 | | 人數 ▶ 雙數 |

157

067 抽樹

此遊戲適合在〈立樹〉之後接著進行。

1 在完成〈立樹〉之後，直接開始進行。
2 遊戲規則是每個組員輪流抽掉一根樹枝。
3 中間的樹枝因支撐不穩而先倒下的組別就輸了。
4 完成〈立樹〉和〈抽樹〉兩個遊戲後，請孩子們分享自己的感受與想法。

▶ 生態系統失去平衡的過程，有時候眼睛是看不出來的，但當達到自然無法承受的界線時，可能會在瞬間完全瓦解。
▶ 〈立樹〉和〈抽樹〉兩個遊戲很適合用來說明生態系統中平衡的重要性。
▶ 小心翼翼地抽取樹枝的過程，可以培養孩子的專注力。

|季節▶不拘| |地點▶不拘| |人數▶雙數|

068 架樹塔

培養創意和合作精神。

1 請孩子各自撿一根樹枝。
2 比較樹枝的長短之後,讓長度最接近的兩人一組。有需要的話,也可以稍微修剪樹枝,讓長度接近。
3 兩人進行猜拳後,贏的和輸的分成兩組,這樣每組的樹枝總長度就會差不多。
4 這不是量長度的遊戲,而是哪一組將樹塔架得更高的遊戲。
5 由於僅靠樹枝當支架可能不易穩固,因此每組提供兩條手帕作為輔助工具,讓孩子們自由運用。
6 規定時間到了之後,請大家停止動作,確認哪一組的塔比較高。

▶ 引導孩子觀察樹枝的粗細和長度,思考如何在不倒塌的情況下堆疊得更高。
▶ 手帕的使用方式不同,堆疊出來的塔的高度也可能不一樣,鼓勵孩子們集思廣益。
▶ 可以依照情況提供更多手帕。

|**準備物品** ▸ 手帕 4～6 條| |**季節** ▸ 不拘| |**地點** ▸ 有樹枝的森林|
|**人數** ▸ 雙數|

069 搬石頭

培養創意和合作精神。

1　請孩子各自撿一個樹枝回來。
2　以 5 公尺為間隔排出兩個正方形，並在其中一個正方形裡放進幾個不同大小的石頭。
3　不能用手和腳，只使用樹枝把石頭搬到旁邊空著的正方形裡。搬動的過程石頭必須離地，不能用滾動的方式。

- ▶ 準備五個由小到大、甚至有點重量的石頭。
- ▶ 為了遊戲的公平性，請規定大家都使用直的樹枝，避免使用容易搬運石頭的「Y」字形樹枝。
- ▶ 如果人數較多，可以分組進行，並計時看哪一組搬得更快。

|季節▶不拘| |地點▶不拘| |人數▶雙數|

070 用樹枝釣魚

激發創意,並培養團隊精神。

1. 主持人在地上畫一個圓,稱之為「湖水」。
2. 撿一些樹枝,折去樹枝上的細枝,將其當作「魚」並放入湖中。
3. 分成兩組,每組製作一個魚缸。
4. 各自拿著釣竿釣魚,最後確認哪一組釣到的魚最多。
5. 也可以加入「傳遞」的環節:前面的人負責釣魚,後面的人將釣到的魚傳遞到魚缸裡。

▶ 當作釣竿的樹枝,最好不要選擇太粗的。
▶ 可以將小樹枝用各種方式折彎放入,討論哪種「魚」比較容易釣起來。
▶ 也可以用樹葉代替樹枝,用樹枝穿過樹葉的方式來釣魚。

| 季節 ▶ 不拘 | | 地點 ▶ 不拘 | | 人數 ▶ 20人上下 |

071 運水

各自扮演好自己的角色,就能完成很有意義的事情。

1. 在可以取得水源的地方,如小溪或水龍頭旁進行遊戲。
2. 將孩子們分為「根」「莖」「葉」三組。根組靠近水邊,葉組在離水邊 10 公尺處,莖組在兩組之間,排成一列。
3. 根組要用手盛裝水,傳遞到最前面莖組成員的手中,該成員再把水傳遞給下一個莖組成員,最後一個莖組成員要把水傳遞給葉組,葉組要在地上挖土,把土和水混合。
4. 葉組用混合了水的泥土,揉成漂亮的餅乾。

▶ 當植物用根吸收水分並送到葉子,葉子就會用這些水分進行光合作用,製造養分。用泥土揉成的餅乾象徵著養分。

▶ 這是可以接觸水、土和泥土的遊戲。

▶ 當根、莖、葉各司其職,植物就能健康生長,並製造出我們需要的養分和氧氣。以此提醒孩子們,扮演好自己的角色的重要性。

| 季節 ▶ 春天～秋天 | 地點 ▶ 有水的地方 | 人數 ▶ 20 人上下 |

072 走獨木橋

體會讓步和合作的重要性。

1. 在有長樹幹的森林進行。
2. 孩子們在樹幹的兩端排隊,一對一過橋。
3. 兩人全都成功過橋是 100 分,只有一個人過橋是 10 分,兩人都沒能過橋是 0 分。
4. 可以多次嘗試,讓孩子們用不同的方法來進行挑戰。

▶ 兩邊同時出發之前,可以先讓每個孩子單獨過一次獨木橋,增加熟悉感。

▶ 如果兩個孩子在獨木橋中間相遇,兩人同時過橋會變得非常困難。必須有一個人先下去,另一個人才能過去。在這個過程中,孩子們會發現互相讓步和合作才是成功的關鍵。請等待孩子自己領悟這個道理。

|季節 ▶ 不拘| |地點 ▶ 森林內| |人數 ▶ 15人以內|

073 換位置

在狹小的空間裡，透過換位置變得更親近。

1. 請孩子從森林裡拿一個自然素材。
2. 將自然素材放在布上，然後並排站在長椅或樹幹上。
3. 主持人選擇布上的一個自然素材，並把它搬到最旁邊，那個自然素材的主人也要跟著換位置。
4. 在換位置的過程中，如果掉下去或腳碰到地面就出局。

▶ 在狹小的空間裡換位置沒有那麼容易，其他人也都要幫忙挪動一下，為對方讓出空間。在森林裡可以使用樹幹，在公園裡則可以使用長椅。

▶ 如果是小學生，可以不用請他們拿自然素材，直接說出指令（例如：按照身高排列、按照生日順序排列、按照姓名筆劃排列等）。

| 準備物品 ▶ 布 | 季節 ▶ 不拘 | 地點 ▶ 森林內、公園 | 人數 ▶ 15人以內 |

074 滾橡實

透過滾橡實摸摸土地，也能跟朋友變得更熟。

1. 分成兩組，每組給一顆橡實。
2. 主持人在地上畫一個大的正方形。
3. 正方形裡放入石頭或木塊等障礙物。
4. 在正方形的角落指定兩組的陣營起點；一組的起點即為另一組的終點。
5. 每個組員輪流彈橡實，最先將橡實彈到對方陣營起點的小組獲勝。
6. 若將橡實彈到正方形外面，或是碰到了障礙物，就要回到起點重新開始。

▶ 橡實不僅是人類的食物，還是花栗鼠、松鼠、野豬、喜鵲、浣熊等動物的食物，因此橡實要成長為橡樹並不容易。
▶ 讓組員自行決定順序，依序輪流彈橡實。
▶ 可以在障礙物上貼上野豬、浣熊、松鼠等文字或貼紙。

| **準備物品**▸橡實 | **季節**▸不拘 | **地點**▸不拘 | **人數**▸雙數 |

075 打造祕密基地

不分勝負，全體一起打造祕密基地。

1. 觀察環境，討論哪裡適合打造祕密基地。
2. 各自說明為什麼要選擇那裡，然後交換意見。
3. 確定地點之後，一起討論材料或形狀等，打造獨一無二的祕密基地。
4. 基地裡面需要有足夠的空間，最重要的是要很牢固，才不會坍塌。
5. 完成後，全部的人都能坐進去才算成功。

- ▶ 年紀較小的孩子可能很難蓋出牢固的基地，需要主持人幫忙。
- ▶ 可以將建造過程與鳥類或動物築巢進行比較，並引導相關討論。
- ▶ 這是一項適合定期共學上課的孩子們，在初期進行的遊戲活動，能增進互動與團隊合作。
- ▶ 祕密基地具有避難所或據點的功能。

| 季節 ▸ 不拘 | 地點 ▸ 森林內 | 人數 ▸ 20人以內 |

藝術創作遊戲

「哇！你做得真好！」聽到這樣的讚美或讚嘆，會讓人心裡感到非常愉快。我們在進行藝術創作時，也會感到快樂。從小就接觸藝術創作遊戲是很有益的，不僅能親近大自然，還能讓手部的感覺變得更加敏銳，表達能力也會變得更豐富。一起來玩簡單的藝術創作遊戲，同時創造出令人讚嘆的作品吧！

076 森林展覽會

找出美麗的風景,並使其更加引人注目。

1. 請孩子各自撿一根樹枝。
2. 比較樹枝的長短之後,讓長度最接近的兩人一組。
3. 然後再將兩組變成一組。四個人一起用樹枝組成四邊形的相框。
4. 四個人一起走在森林裡,找到漂亮或有趣的景點時,就把相框放在上面。
5. 大家一起欣賞並討論作品。

▶ 這是一個能讓孩子觀察森林、並將那份感動好好留存在心裡的遊戲。也可以透過為作品命名來提升藝術表達能力。

▶ 如果沒有樹枝,也可以使用紙或繩子來製作相框。

▶ 會寫字的孩子,可以在樹葉上寫下作品的名稱。

| **準備物品** ▶ 簽字筆 | **季節** ▶ 不拘 | **地點** ▶ 森林、公園 |
| **人數** ▶ 15 人以內 |

077 找出同樣的顏色

找出和手上的物品顏色相同的東西。

1. 準備色鉛筆。
2. 每人分一根色鉛筆,請孩子們找出與色鉛筆顏色相似的自然素材。
3. 自然素材只要有某部分的顏色與色鉛筆相似即可,不需要完全相同。

▶ 也可以讓孩子們去尋找和自己的鞋子或衣服顏色相近的自然素材,提升他們的色彩觀察力。

和上衣同樣的顏色！

我是鞋子！

|準備物品 ▶ 色鉛筆 |　|季節 ▶ 不拘 |　|地點 ▶ 森林、公園 |
|人數 ▶ 20 人以內 |

181

078 楓葉漸層

用楓葉創作漸層的作品。

1 準備一塊布。
2 在布的兩端各放一片綠色和黃色的葉子。
3 請孩子在兩片葉子之間放入其他葉子,使它們形成漸層效果。
4 最後,會完成一個想像中更漂亮的楓葉漸層作品。

▶ 大自然擁有各種顏色,唯有會仔細觀察並欣賞的人才看得見。

▶ 當你將葉子排成一排之後,可以試著找出更多顏色的葉子並把它們排列成圓形,就會變成美麗的色相環。如果樹葉的顏色不夠多,也可以加入其他自然素材,石頭或菇類也擁有讓人意想不到的色彩喔!

| **準備物品** ▸ 布 | | **季節** ▸ 秋天 | | **地點** ▸ 森林、公園 |
| **人數** ▸ 20 人以內 |

079 拓印樹葉

自然素材也可以成為顏料。

1. 將大一點的紙分給每個人，請大家摺成一半。
2. 在摺成一半的紙中央夾入一片樹葉，這時將葉脈明顯的背面朝上。
3. 把紙放在平坦的地方，然後用從樹上摘下來的一片葉子取代顏料，摩擦上方。
4. 完成後，大家一起展示並討論各自的拓印作品。

- ▶ 也可以利用泥土、樹枝等其他自然素材來拓印。花瓣或草葉雖然能呈現漂亮的顏色，但在摩擦時容易被壓碎，因此不容易拓印出清晰的紋理。
- ▶ 使用有顏色的葉子進行拓印時，可以直接印出顏色。孩子們會發現，自然素材也能像顏料一樣展現色彩。
- ▶ 也可以先在紙上畫畫，然後用各種自然素材為圖畫上色。

樹葉就像是水彩呢！

用各種自然素材塗顏色。

| **準備物品** ▶ 紙 | **季節** ▶ 不拘 | **地點** ▶ 森林、公園 |

| **人數** ▶ 20 人以內 |

080 這個像什麼呢？

用樹皮玩猜圖形遊戲。

1. 在松樹或櫸樹這種樹皮容易剝落的樹旁進行遊戲。
2. 請大家觀察幾何形狀的樹皮，挑選出看起來像某種東西的樹皮並撿回來。
3. 不能告訴別人它像什麼，只能自己心裡知道。
4. 等全部的孩子都到齊後，一一讓大家猜猜看撿回來的樹皮像什麼。

▶ 可以撿拾掉落的樹皮，也可以輕輕剝下快要脫落的樹皮。比起其他自然素材，樹皮的形狀更多元，非常適合玩這個遊戲。

▶ 有時孩子被猜中了答案也會調皮否認，為避免這種情況，可以要求孩子出問題前先將答案悄悄告訴主持人，或者讓會寫字的孩子先把答案寫在手心上。

▶ 也可以觀察像法桐或光皮木瓜樹這種樹皮斑駁的樹木，從中找出像某種形狀的圖案。

| 季節 ▶ 不拘 | 地點 ▶ 森林、公園 | 人數 ▶ 20 人以內 |

081 變出無限可能

適合在〈這個像什麼呢？〉遊戲後接著進行。

1. 把剛剛撿來的樹皮放在白布上。
2. 主持人說要拼成「站立的人」，然後用樹皮拼拼看。
3. 挑戰看看還能拼出什麼。

> ▶ 不要將樹皮重疊或折斷，而是保留它原本的形狀，像畫畫一樣創作出各種圖案。可以把這個活動想成類似七巧板的遊戲。

|準備物品▶布| |季節▶不拘| |地點▶森林、公園|
|人數▶20人以內|

189

082 森林設計師

用自然素材設計衣服。

1. 將大一點的紙分給每個人,請大家摺成一半。
2. 在摺好的紙的封面,畫一個穿衣服的人。
3. 用美工刀把衣服的部分沿線割下來。
4. 在裡面那頁貼上自然素材,設計衣服。
5. 將後面那張紙撕下來,跟朋友玩換穿衣服的遊戲。

▶ 也可以拉一條繩子,將作品用夾子夾起來。選出設計最出色的服裝設計師,並給予簡單的獎勵也很有趣。

▶ 可以把前面那張衣服部位鏤空的紙,當成是可隨身攜帶的相框,放置在漂亮的景物上。

▶ 許多藝術家從大自然中獲得靈感,設計師也經常從動植物的形狀和花紋中取材。

只把衣服的地方用美工刀割下來。

在裡面那頁黏上自然素材。

獨特的衣服完成了！

🍄 |**準備物品**▸紙、美工刀| |**季節**▸不拘| |**地點**▸森林、公園|
|**人數**▸20人以內|

083 森林服裝秀

穿上用自然素材創作的衣服吧!

1. 將樹葉剪成衣服的形狀。
2. 請朋友站遠一點,利用距離錯位技巧,將自然素材做成的衣服「穿」到朋友身上。
3. 用手機或攝影機相機拍照留念,會更有趣喔。

▶ 可以利用前面〈森林設計師〉遊戲中剪下來的衣服紙張,在上面添加自然素材裝飾來繼續進行創作遊戲。

▶ 除了衣服,還可以製作帽子、雨傘等其他配件,並運用距離錯位技巧拍攝照片,讓活動更有趣。

也可以用紙。

🍄 |準備物品▶剪刀| |季節▶不拘| |地點▶森林、公園|
|人數▶20 人以內|

084 是不是這裡？

閉上眼睛，聆聽敲擊樹木的聲音。

1. 找一棵倒下來的樹幹，用樹枝敲擊樹幹的不同位置。
2. 請孩子們閉上眼睛聆聽。
3. 主持人在樹幹的某個特定位置敲擊，請孩子記住這個聲音，然後標示敲擊的地方。
4. 接著，主持人敲擊樹幹的不同部位，當孩子認為聽到那個特定位置的敲擊聲時，就喊「停」。
5. 每個人輪流聆聽並回答，看誰最接近答案。

- ▶ 樹幹的粗細和硬度因不同部位而異，所以敲擊時發出的聲音也會不同。
- ▶ 此遊戲可以全體閉上眼睛一起猜聲音，也可以讓每個小朋友單獨挑戰。
- ▶ 如果有石頭，也可以玩「石頭鼓」的遊戲。不同大小的石頭，用樹枝敲擊出來的聲響也會不一樣。接著可以進行下一個〈製作森林樂器〉遊戲。

也可以敲擊石頭。

演奏木頭爵士鼓～

聲音不一樣～

敲擊各種物品！

| 季節 ▶ 不拘 | 地點 ▶ 安靜的森林 | 人數 ▶ 15 人以內 |

085 製作森林樂器

適合在〈是不是這裡？〉之後接著進行。

1. 告訴孩子森林裡的自然素材能發出各種聲音，並提議大家一起用自然素材製作樂器。
2. 請給予充足的時間讓孩子們製作樂器。
3. 請孩子輪流介紹自己的樂器名稱和演奏方式。
4. 大家一起開演奏會。

▶ 音樂遊戲是一種低競爭性的遊戲。多人一起進行時，若能齊心協力演奏出和諧的樂章，將成為一次美好的體驗，就像生態系統和我們生活的世界彼此融洽時一樣美好。

▶ 在演奏會中安排一位指揮來指揮大家，可以為遊戲增添更多趣味。

| 季節 ▶ 不拘 | | 地點 ▶ 安靜的森林 | | 人數 ▶ 15 人以內 |

197

086 森林作曲家

和朋友一起創作一首美妙的歌曲。

1. 依照人數創作相應字數的歌詞。（如：八個人就創作八個字的歌詞 → 美麗森林 快樂森林）
2. 將階梯的最下面一層稱為「Do」，往上一層是「Re」……依序一直到高音「Do」。
3. 輪流丟松果，確認自己丟到哪一個音階。
4. 將歌詞配上音階，用直笛演奏，大家一起唱出創作的歌曲。

▸ 可以用手機錄音，或將演奏的過程錄製下來，保留創作成果。

▸ 如果沒有階梯，可以用樹枝分隔，做成平面的階梯，然後丟松果決定音階。

▸ 除了可將歌曲記錄在紙上，也可以將松果插在樹枝上做成音符，並將歌詞寫在樹葉上，或是用樹枝將樂譜和歌詞直接寫在地上來創作歌曲。

有階梯就在階梯進行，如果沒有階梯就在平地用樹枝分隔，決定音階。

可以用自然素材創作樂譜。

| **準備物品** ▶ 直笛、紙、筆 | **季節** ▶ 不拘 | **地點** ▶ 安靜的森林、公園 |

人數 ▶ 20人以內

087 完成圖畫

一邊完成圖畫一邊培養聯想能力。

1　主持人在紙上畫一個未完成的人臉。
2　出示給孩子看之後,請孩子完成這幅畫。
3　請孩子好好觀察,然後用自然素材完成其餘部分。
4　撿拾自然素材來完成眼睛、鼻子和嘴巴。

▶ 未完成的畫不一定是人臉,也可以畫其他東西。
▶ 不一定要畫在紙上,也可以畫在地上。
▶ 完成圖畫之後,也可以用自然素材來裝飾畫作周圍。

也可以善加利用周遭的大自然。

|準備物品▶紙、筆| |季節▶不拘| |地點▶森林、公園|
|人數▶20人以內|

088 落葉雕塑家

利用地上的落葉完成精彩的雕塑作品。

1 在有落葉的地方進行。
2 利用落葉排出圓、三角形、愛心等形狀。
3 請孩子自由發揮，各自用落葉創作作品。

- ▶ 比起有厚厚一層落葉的地方，找公園或平地有少量落葉的地方比較好。
- ▶ 可以用腳或樹枝收集落葉來進行。
- ▶ 也可以用其他自然素材來取代落葉。

| 季節 ▶ 不拘 | 地點 ▶ 有落葉的森林、公園 | 人數 ▶ 20 人以內 |

089 楓葉色紙

秋高氣爽，剪下楓葉來玩吧！

1 太過乾枯的楓葉或綠色的楓葉都不適合這個遊戲。
2 用剪刀將葉子剪出自己想要的形狀。
3 請孩子自由發揮，各自用落葉完成作品。

▶ 可以從簡單的開始，漸漸提高難度。
▶ 可以鼓勵孩子多多觀察樹葉，利用樹葉原本的紋路或形狀來創作。
▶ 剪出動物的形狀後，似乎就有故事可以說了，對吧？
▶ 也可以把剪下來的葉子放在布上創作故事，或是將它們貼在紙上創作繪本。

可以用剪下來的葉子創作故事。

| 準備物品 ▶ 剪刀 | 季節 ▶ 秋天 | 地點 ▶ 有樹葉的地方 |
| 人數 ▶ 20 人以內 |

090 楓葉彩繪玻璃

用楓葉創作漂亮的彩繪玻璃。

1 這是用楓葉玩的遊戲。
2 在黑紙上畫下想要的圖案,然後用刀割下來。
3 配合割下來的位置,放置各種顏色的楓葉並黏上去。
4 完成後,將作品拿到陽光下照射,效果就像漂亮的彩繪玻璃喔!

▶ 請根據孩子的年齡決定圖案的難易度。
▶ 拿到陽光下照射時,半透明的楓葉會顯得格外美麗,可以讓孩子感受到楓葉之美。

※ 此圖為韓文的「自然」之意。

| **準備物品** ▶ 黑色的紙、美工刀、膠水 | | **季節** ▶ 秋天 |
| **地點** ▶ 有樹葉的地方 | | **人數** ▶ 20 人以內 |

091 變成毛毛蟲

想像跟毛毛蟲一樣啃食樹葉,嘗嘗樹葉的味道。

1. 建議用葛藤的葉子。
2. 摘下葛藤的葉子,並將其折疊好幾次。
3. 每個人都像毛毛蟲一樣,假裝咬一口折疊過的葛藤葉。(實際上可用手搓揉葉子,留下痕跡。)
4. 展開葉子,會看到很多紋路,一起欣賞及討論紋路。

- ▶ 葛藤的葉子比較容易折疊,而且背面和正面的顏色不同,因此紋路會很明顯。
- ▶ 若有好奇的小朋友想真的咬看看葉子,葉子被牙齒咬後會直接斷裂,不會留下痕跡。
- ▶ 一邊用手搓揉葛藤的葉子、一邊感受葉子的氣味是個不錯的體驗。
- ▶ 請務必告訴孩子,不是所有的葉子都可以放進嘴裡品嘗味道或直接聞嗅,應要先詢問過大人。

| 季節 ▶ 夏天~秋天 | 地點 ▶ 有葛藤的地方 | 人數 ▶ 20 人以內 |

092 樹的生日派對

一起來幫樹慶生吧！

1. 大家一起尋找今天要過生日的樹。
2. 找到樹之後，大家要幫樹慶生。
3. 樹喜歡泥土，所以就用泥土來做生日蛋糕吧！
4. 做完泥土蛋糕之後，用自然素材來裝飾它。
5. 一起唱生日快樂歌。

- ▶ 在生意盎然的春天，可以透過新芽找到一棵適合慶祝生日的樹木。
- ▶ 也可以選擇草或其他生物來當壽星。
- ▶ 如果當天有人生日，也可以一起為他慶生。
- ▶ 在土裡加一點水會更容易做成蛋糕。
- ▶ 在活動過程中，可以請孩子找一些自然素材當作生日禮物送給樹。

| 季節 ▶ 春天 | | 地點 ▶ 不拘 | | 人數 ▶ 20 人以內 |

093 用水畫畫

盡情用水作畫。

1. 在有水源的地方進行。
2. 找一顆平坦的石頭代替紙。
3. 用手指沾水,在石頭上畫出圖案。
4. 也可以接力畫畫:一個人畫一部分,另一個人接著完成。

▶ 如果找不到有水的地方,就事先準備水。
▶ 太陽較大時,導致畫出的圖案很快就晒乾不見的話,就再畫一次囉。
▶ 也可以在牆上作畫。

用這個來畫畫好嗎？

有水呢！

也可以在牆上作畫。

| 季節 ▶ 不拘 | 地點 ▶ 有水的地方 | 人數 ▶ 20 人以內 |

213

094 用土畫畫

泥土也可以成為很棒的顏料！

1. 將一滴水滴在紙上。
2. 用嘴巴吹氣或晃動，用水畫出各種紋路。
3. 立刻把土撒上去。
4. 將土抖落後，紙上會出現美麗的圖案。
5. 請孩子分享自己的畫看起來像什麼，並展示自己的作品。

▶ 等水乾後，泥土更容易抖落。如果想長期保存，可以用膠水代替水。

▶ 也可以用手指沾水，在紙上畫出想要的圖畫，再撒上泥土。

立刻把土倒在水上。

看起來好像花！

你的像恐龍！

| 準備物品 ▶ 紙 | 季節 ▶ 不拘 | 地點 ▶ 有土的地方 |
| 人數 ▶ 20 人以內 |

095 年輪拼圖

以自然素材製作玩具。

1. 將直徑 5 公分以上的樹幹,切成約 1 公分厚的木片。
2. 在切好的木片上畫圖。
3. 畫好之後,用石頭把木片敲碎。
4. 嘗試拼湊碎片,完成拼圖!

- ▶ 敲碎時要背面朝上,以免破壞圖案。
- ▶ 也可以將大家的拼圖混合在一起拼,增加遊戲難度。

用石頭敲很容易裂開。

🍄 |**準備物品** ▶ 鋸子、簽字筆 | |**季節** ▶ 不拘 | |**地點** ▶ 有樹幹的地方 |
|**人數** ▶ 20 人以內 |

結尾收心遊戲

遊戲進入尾聲時，其實不一定要做特別的活動。可以透過分享當天的感受，或是進行一個總結性的遊戲來思考自然與人類之間的關係，為一天的活動畫下完美句點。

096 授粉猜拳

了解花和昆蟲的關係，同時和朋友進行肢體遊戲。

1. 兩人一組扮演「花」，進行猜拳。
2. 如果兩個人出不同的拳，代表授粉失敗；如果出相同的拳，則表示授粉成功。
3. 若雙方都出剪刀，一起說「你好」；雙方都出石頭，一起說「很高興認識你」；雙方都出布，一起說「我喜歡你」。
4. 說「你好」時，兩個人站著打招呼；說「很高興認識你」時，兩人握手；說「我喜歡你」時，互相擁抱。
5. 了解每個孩子扮演什麼花、成功授粉幾次，然後請他們分享感受。

▶ 建議在繁花盛開的季節進行。
▶ 在遊戲開始前，請先講解花與昆蟲的共生關係。
▶ 在遊戲過程中，一般孩子們出布並說「我喜歡你」的頻率會比較高。這是一個可以讓朋友互相擁抱的遊戲。

同時出「剪刀」時

你好～

同時出「石頭」時

很高興認識你～

同時出「布」時

我喜歡你～

| 季節 ▶ 不拘 | 地點 ▶ 森林、公園 | 人數 ▶ 不限 |

097 你今天過得好嗎？

用自然素材創作並表達自己今天的感受。

1. 今天的森林遊戲來到尾聲了，請大家回想自己的心情。
2. 大家一起分享意見，用一句話或簡單的詞語總結。（例如：「有趣又開心」、「森林真好玩」）。
3. 用自然素材拼出自己說出的句子或詞語。

▶ 用類似的自然素材直接呈現出那個字會更有趣。（例如：直接用樹枝擺出「卜」，或用石頭當「口」等）

▶ 參與人數較多時，可以分組進行。

▶ 可以用膠水將自然素材黏貼在紙上進行裝飾。如果沒有準備物品，也可以直接在地面上創作，或直接用手拿著展示。

※ 孩子可用筆或自然素材來創作表達心情。

| 準備物品 ▶ 紙、筆、膠水 | | 季節 ▶ 不拘 | | 地點 ▶ 不拘 |
| 人數 ▶ 不限 |

098 抓拐杖

透過樹枝遊戲，增進對生態系統的理解。

1. 請孩子各自撿適合當拐杖的樹枝回來。
2. 像拿拐杖一樣將樹枝撐在地上，圍成一圈站好。
3. 當主持人喊出口令時，孩子將自己的拐杖立穩後放開，然後迅速去抓住旁邊人的拐杖，不能讓它倒下來。
4. 沒能及時抓住拐杖的人就出局。出局者的位置不遞補，剩餘的孩子在原位繼續進行遊戲。
5. 最後剩下的人獲得勝利。

▶ 生態系統中的每一個角色都很重要，每個角色都有其作用，如果缺少了其中一個，就會破壞平衡。
▶ 遊戲規則是：右手抓自己的拐杖，左手抓別人的拐杖。年幼的孩子可以用雙手。
▶ 如果站得太近，遊戲會很難進行，建議與旁邊的人保持約 1 公尺的距離。

| 季節 ▶ 不拘 | | 地點 ▶ 不拘 | | 人數 ▶ 20 人上下 |

099 種樹的人

透過蹲下、站立的遊戲來了解生態。

1. 選出兩人，一人是「砍樹的人」、一人是「種樹的人」。
2. 將剩下的人分成兩邊，一邊是「被砍的樹」，另一邊是「被種的樹」。被砍的樹要蹲下來，被種的樹要站起來。
3. 主持人喊「開始！」時，砍樹的人和種樹的人就要到處走動進行工作。砍樹的人要讓站著的人蹲下，種樹的人要讓蹲著的人站起來。
4. 當主持人喊「停！」時，計算被砍的樹和被種的樹哪一邊比較多。

▶ 我們在生活中無法避免砍伐樹木，但必須在砍伐的同時，重新種植、培養和保護它們。

▶ 樹木之間應保持約 1 公尺的距離，如果太近或太遠都不容易進行遊戲。

▶ 遊戲規則是必須用雙手按住對方的肩膀，或者輕輕扶起；如果只用一隻手觸碰或輕輕碰到，樹木就不可以移動。

| 季節 ▶ 不拘 | 地點 ▶ 不拘 | 人數 ▶ 20人以內 |

100 全都在種子裡

小小的種子裡,藏著一棵大樹。

1. 請孩子們從森林裡撿果實,一起討論、想像種子裡會有什麼東西。
2. 依據植物的五種器官(花、果實、根、莖、葉),將孩子們分成 5 組(每組人數可以不同,讓孩子們選擇自己喜歡的植物器官)。
3. 利用繩子在地上圈一個圓,稱為「種子」。
4. 只有主持人喊到的組別才能進入圓圈。如果碰到繩子或腳踩到圓圈外就被淘汰。
5. 把五組都叫進小圓圈裡,全當所有人都進去後,一棵樹就完成了。

▶ 如同小小的種子會長成大樹一樣,告訴孩子,小小的我們也要像大樹一樣,培養並實現我們的夢想。

▶ 在狹小的空間裡要容納多人時,孩子們需要發揮創造力和合作精神。

▶ 此遊戲也可以森林裡的岩石或樹樁上進行。但如果人數太多可能會有點危險,請根據當時的情況進行調整。

| 準備物品 ▶ 繩子 | | 季節 ▶ 不拘 | | 地點 ▶ 不拘 | | 人數 ▶ 不限 |

趣玩大自然 100 個遊戲(符合 SDGS 主題+STEAM 教育)

作　　者：黃京澤
譯　　者：葛增娜
企劃編輯：許婉婷
文字編輯：王雅雯
設計裝幀：張寶莉
發 行 人：廖文良

發 行 所：碁峰資訊股份有限公司
地　　址：台北市南港區三重路 66 號 7 樓之 6
電　　話：(02)2788-2408
傳　　真：(02)8192-4433
網　　站：www.gotop.com.tw
書　　號：ACK016600
版　　次：2025 年 02 月初版
建議售價：NT$380

國家圖書館出版品預行編目資料

趣玩大自然 100 個遊戲(符合 SDGS 主題+STEAM 教育)
/ 黃京澤著；葛增娜譯. -- 初版. -- 臺北市：碁峰資訊,
2025.02
　　面；　公分
　譯自：주머니 속 자연놀이 100
　ISBN 978-626-324-964-6(平裝)

　1.CST：兒童遊戲　2.CST：科學教育
996　　　　　　　　　　　　　　　113018076

商標聲明：本書所引用之國內外公司各商標、商品名稱、網站畫面，其權利分屬合法註冊公司所有，絕無侵權之意，特此聲明。

版權聲明：本著作物內容僅授權合法持有本書之讀者學習所用，非經本書作者或碁峰資訊股份有限公司正式授權，不得以任何形式複製、抄襲、轉載或透過網路散佈其內容。
版權所有．翻印必究

本書是根據寫作當時的資料撰寫而成，日後若因資料更新導致與書籍內容有所差異，敬請見諒。若是軟、硬體問題，請您直接與軟、硬體廠商聯絡。